WET DOG

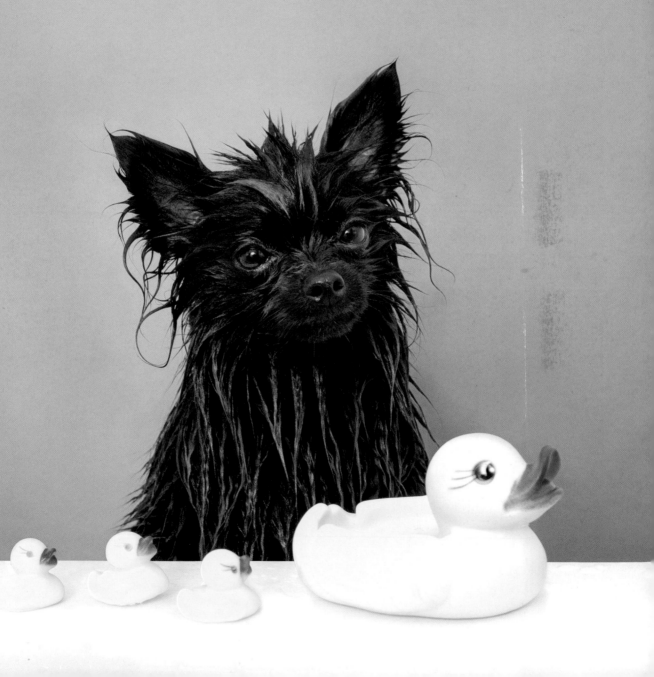

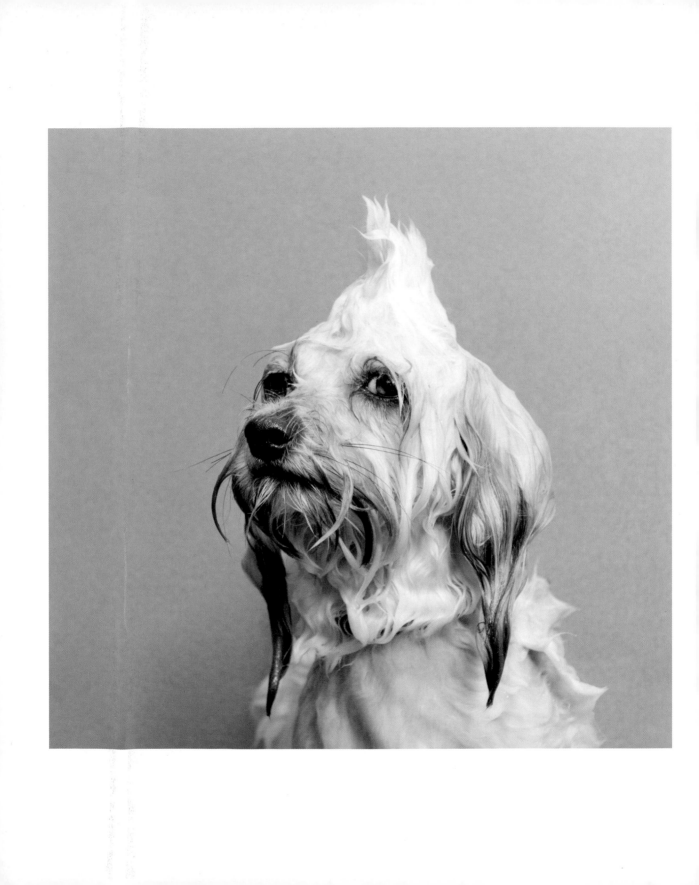

WET DOG

SOPHIE GAMAND

GRAND CENTRAL PUBLISHING

NEW YORK • BOSTON

GRAND CENTRAL PUBLISHING
Hachette Book Group
1290 Avenue of the Americas
New York, NY 10104

HachetteBookGroup.com

Printed in China

Photographs by Sophie Gamand

IM
First Edition: October 2015
10 9 8 7 6 5 4 3 2 1

Grand Central Publishing is a division of Hachette Book Group, Inc.
The Grand Central Publishing name and logo is a trademark of Hachette Book Group, Inc.

The Hachette Speakers Bureau provides a wide range of authors for speaking events.
To find out more, go to www.hachettespeakersbureau.com or call (866) 376-6591.

The publisher is not responsible for websites (or their content) that are not owned by the publisher.

Library of Congress Cataloging-in-Publication Data has been applied for.
ISBN: 978-1-4555-3147-9

TO MY HUSBAND, STEN,
AND MY FAMILY.
WE MAKE A GREAT TEAM!

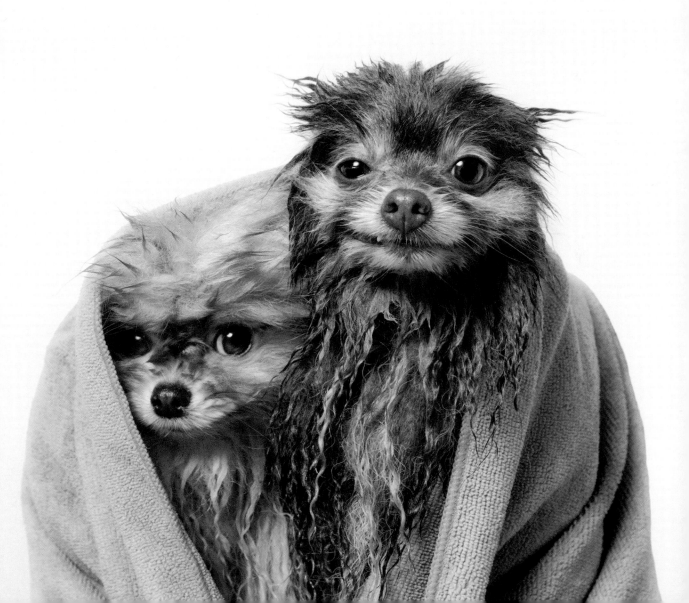

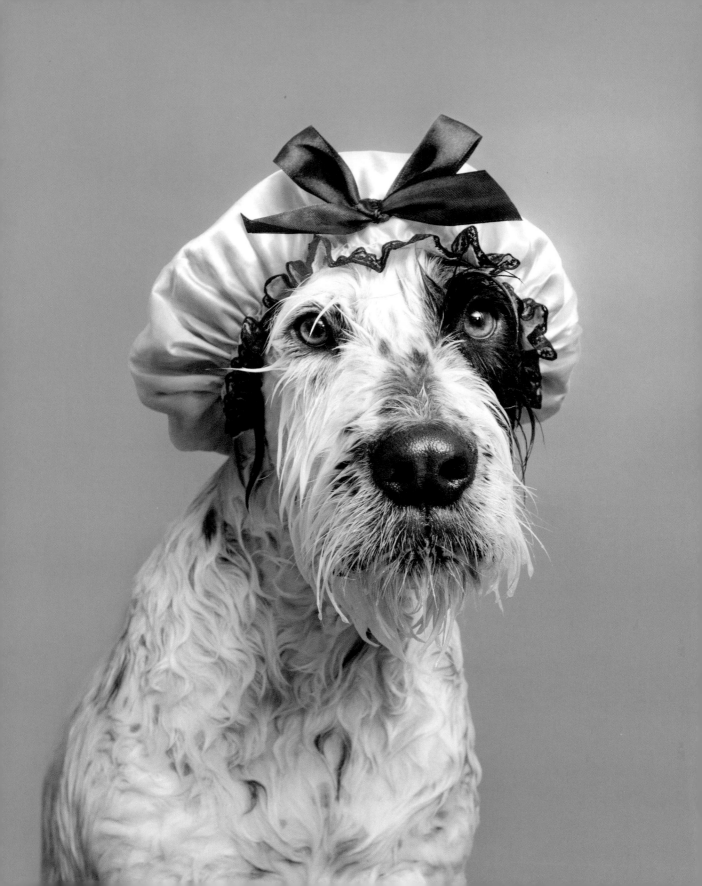

INTRODUCTION

BY SOPHIE GAMAND

There is no experience more humiliating for a dog than taking a bath. Soaking wet, they wiggle themselves out of our soapy grasp in a desperate attempt to escape their fate. Yet at that exact moment when they turn their miserable, sad eyes up at us, wet dogs are the sweetest, most heartwarming creatures in the world. They are angry yet trusting. They want to run away, but they hold on to us tightly in an intense embrace. Indeed, as Ambrose Bierce once wrote, "Wet dogs are the most affectionate creatures in the world."

A long time ago, my dream was to become a veterinarian. I owned all sorts of pets, from my beloved bunny to my collection of snails, which I would study with scientific seriousness. I grew up with dogs: a pair of German shorthaired pointer sisters named Arpège and Ardoise, who lived freely on my parents' property in a charming French village built more than a thousand years ago. The dogs would play in the garden and lounge in the sun all day, chasing lizards and mice. They were not allowed on the sofa or to go upstairs, but I remember, with joy, coming home after school and hearing them jump off the forbidden couch, or the sound of frantic claws on the hardwood floor as they rushed downstairs from our bedrooms. They knew the rules, but they decided to do exactly what they wanted to do as soon as we turned our backs. They were naughty and beautiful. A bath for them was a once-a-year experience. My father would give them a quick hose-down, holding them firmly by their collars as they stood stoically under the powerful stream of cold water.

In 2010, my husband-to-be, Sten, and I moved from Europe to New York City. Uprooted, I had to decide what new direction to take my career. It was an over-whelming time, but I realized that it also provided me with an opportunity to re-invent myself. Photography became a way for me to try to connect with people and take possession of my new surroundings and my new life. I brought my camera outside, and for the first time I aimed it at strangers. But I soon realized I was photo-graphing the strangers' dogs more often than the strangers themselves . . .

A few weeks later, I walked into the Cobble Hill Animal Clinic in Brooklyn and took the picture that would trigger my obsession with dog photography. It was a portrait of a white bulldog with blue eyes peeking out from behind a wall. When I first spotted him, he looked out of place and worried, like a little boy at the dentist. "*Pssst*, you with the camera, do you know what they're going to do to me?" his eyes seemed to ask. After I took that picture I started frantically researching all the things New Yorkers do with, and to, their dogs. The dogs' lifestyles were so different from anything I had ever encountered. Women were walking their dogs around in strollers! Groomers were painting dogs pink! Dog couturiers were creating garments worth thousands of dollars for tiny feisty Chihuahuas! Some dogs were taking antidepressants, while others had their own Facebook pages and busier agendas than mine. What a world I had stepped into! I was determined to explore every facet of it, and to spend the next few years examining the complex and fascinating relationship between dogs and people.

It seems to me that dogs often fill a role for people that other humans no longer can. They have become confidants and partners, substitutes for spouses and children. In big cities like New York, dogs seem to alleviate a person's deep sense of solitude. Humanity has engineered the perfect companion: one who never fails you and who loves you unconditionally. Are dogs still animals when we have imbued them with so many human qualities? This question is central to my photography.

My interest in dog photography has led to my involvement in dog rescue, photographing hundreds of shelter dogs in order to aid the adoption process and to raise awareness and money for animal causes and organizations. The work I did with The Sato Project in Puerto Rico was life changing. For almost two years, I volunteered with them, photographing abandoned and injured dogs on what is referred to as Dead Dog Beach. I fed, petted, and held them on their way to safety.

When they would arrive at the rescue facility, one of the first things we would do was bathe them. I always volunteered for bath time. It was a very intense experience that filled me with both a deep sense of despair and an exultant sense of hope. These baths were the beginning of the dogs' new lives. They didn't enjoy it, but it was their initiation into a world of caring. It was a rite of passage. In exchange for safety, shelter, and food, a dog must follow a long list of human rules: you will not fight; you will not hump inappropriately; you will no longer have fleas, infections, and unhealed wounds; and you will no longer have to scavenge. You will play with plastic toys and sleep on soft bedding. You will go to the bathroom when humans say so, and walk on a leash for the rest of your life. And you will, occasionally, have to endure a bath.

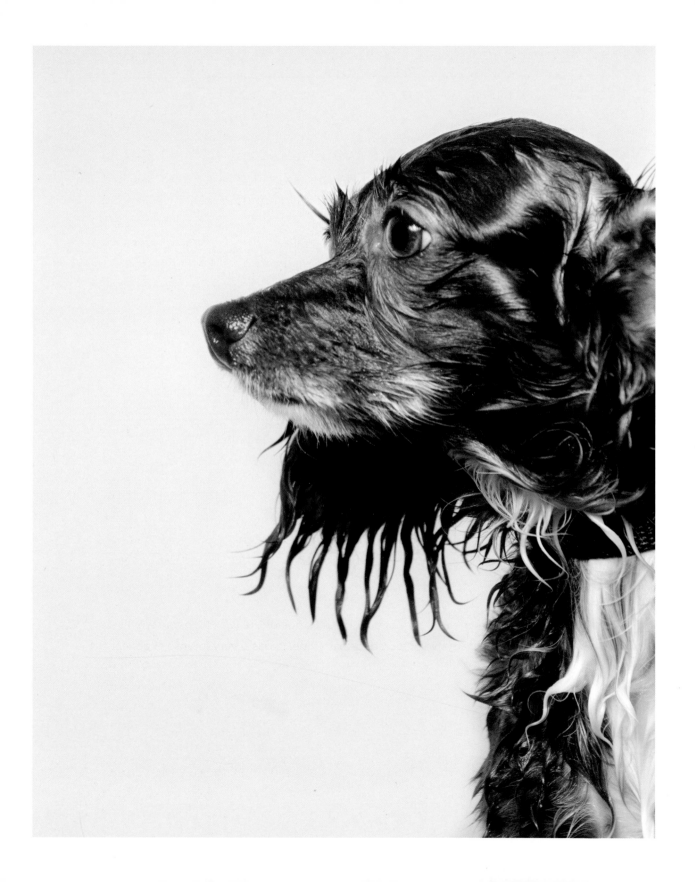

Bath time is a symbol of this unspoken contract between people and domesticated dogs, a pact in which dogs trade their freedom for comfort and safety.

In 2013, I met pet stylist Ruben Santana and his fabulous purple poodle, Dana. He welcomed me into his grooming salon in the Bronx, where I set up a studio for the day. Ruben is extravagant and imaginative, and we were the perfect creative match. As I photographed the grooming process, the dogs would transform before my eyes. When Ruben started bathing his clients, I turned my camera toward the tub. At first I was fascinated by the way the water played with their fur. It was so painterly. But then I noticed the dogs' expressions, and there was no turning back. I photographed their most intimate and poignant moments, their vulnerability and anger, their revolt and submission, and their judgment. I went home that night absolutely exhausted, but eager to go through the photographs. Had I managed to capture the magic of the moment?

My husband peeked over my shoulder. He gasped as he looked at my computer screen. "What is this?"

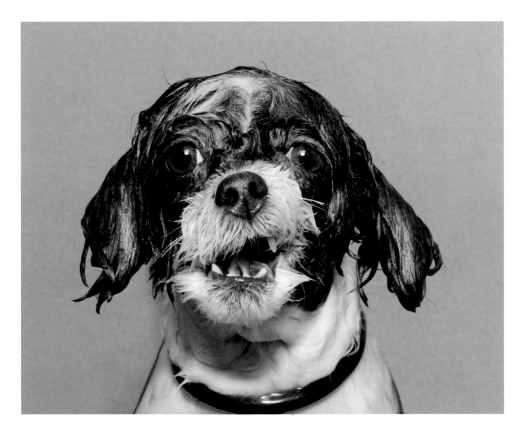

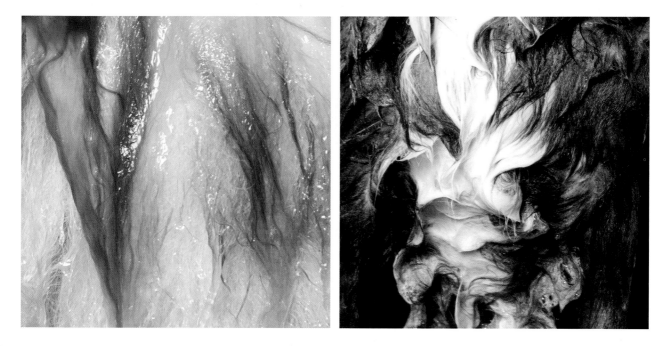

"Wet dogs," I whispered.

The wet dog photographs took me by surprise and changed my life. They quickly gained a major following on the Internet, and my website was registering hundreds of thousands of visitors. In 2014, I won several awards for the series, including a prestigious Sony World Photography Award, which was a huge achievement, especially for dog portraiture. Visiting the winners' exhibition in London, I discovered nine Wet Dog prints lined up on the wall. My hands started to tremble. I giggled and teared up at the same time. The dogs looked so miserable, yet so proud in their attempt to salvage the last bit of dignity they had! I wanted to hug them all and tell them it was going to be okay. As I sat in a corner to take in the scene and spy on the visitors discovering my photographs, I realized they all had a similar reaction. Everyone loves a wet dog.

Soon after I started working on the Wet Dog book, I found another wonderful partner in the fearless, fun, and sparkly groomer Ingrid Olson from Animal Loving Care in Brooklyn. During the next six months, I organized multiple wet dog photo shoots, scouting models in the streets and among my friends.

The book you are about to open is the result of this beautiful adventure. It has been fun, stressful, inspiring, and challenging—everything an adventure should be. Thank you for being a part of it.

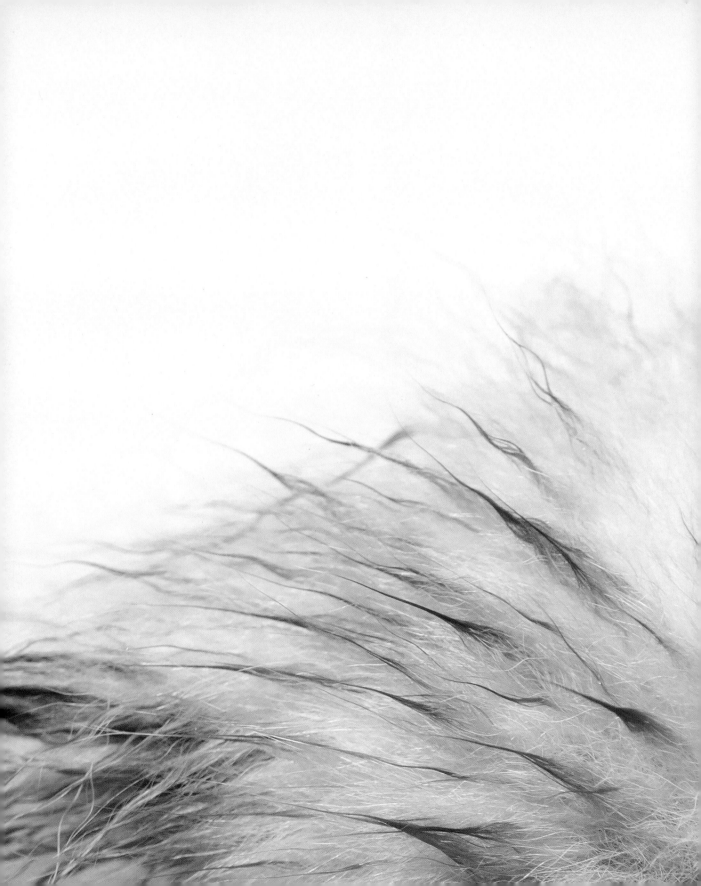

WET DOG

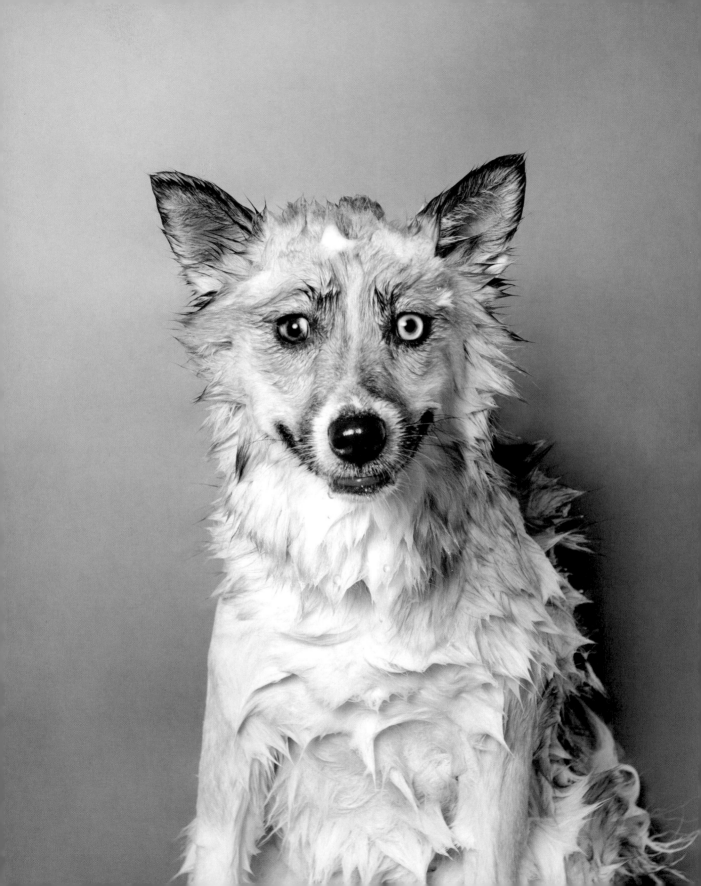

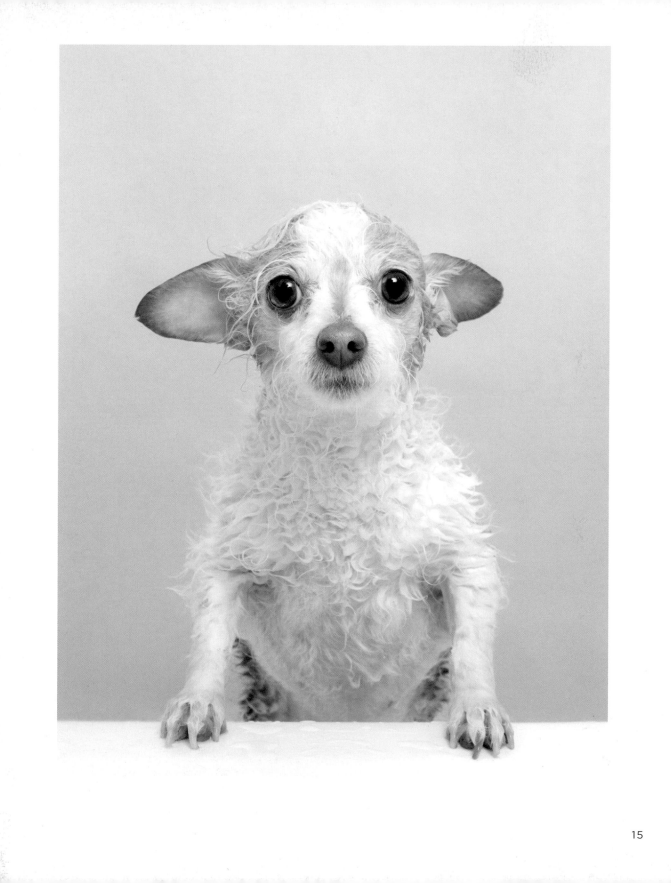

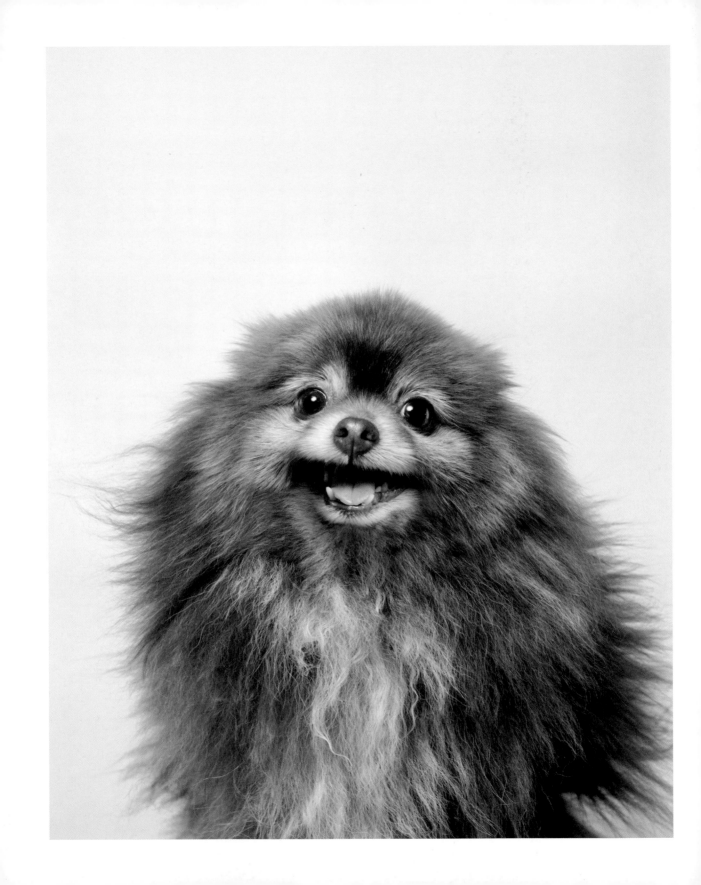

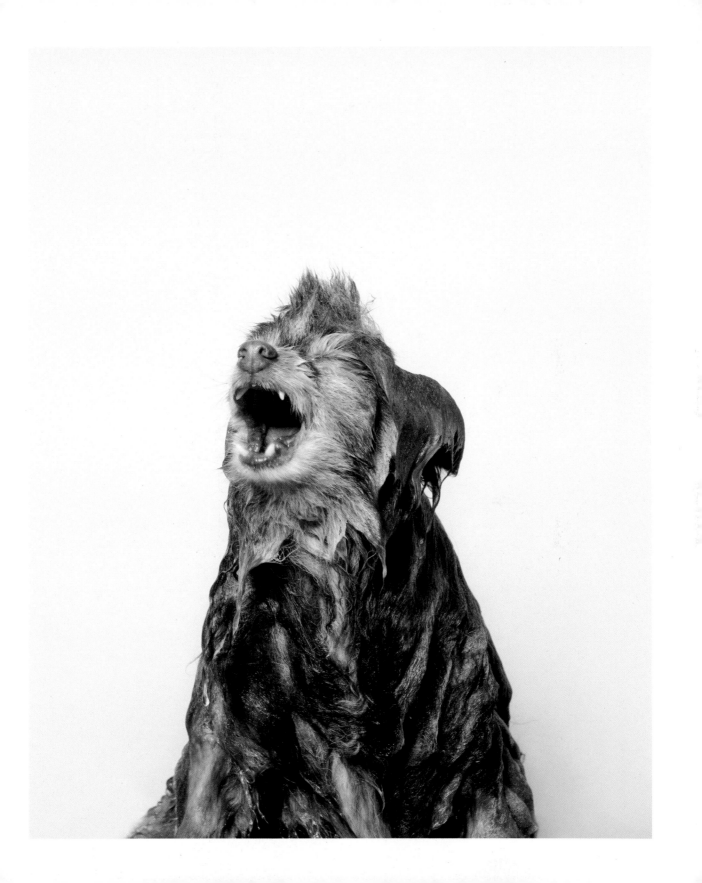

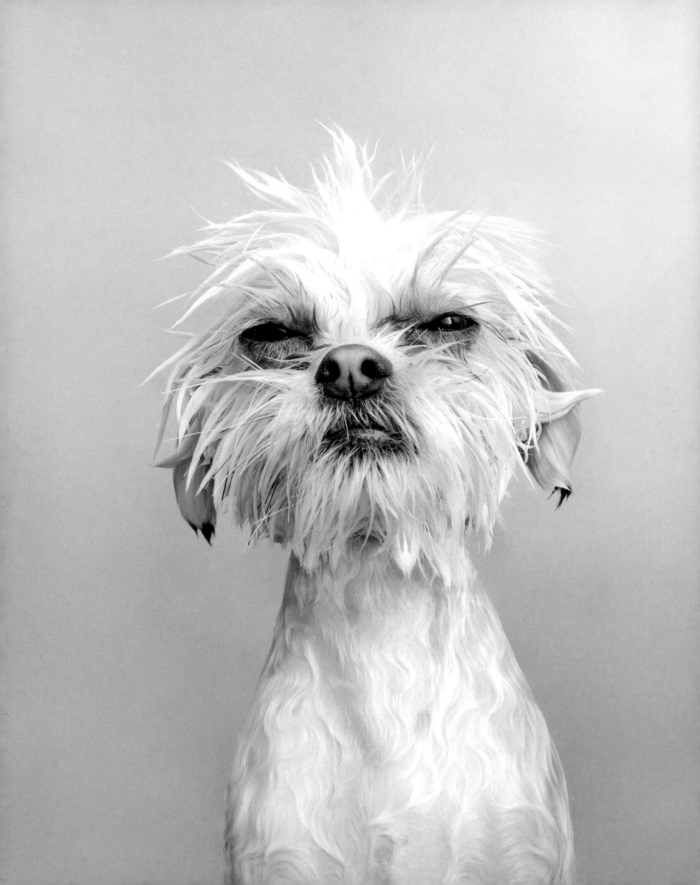

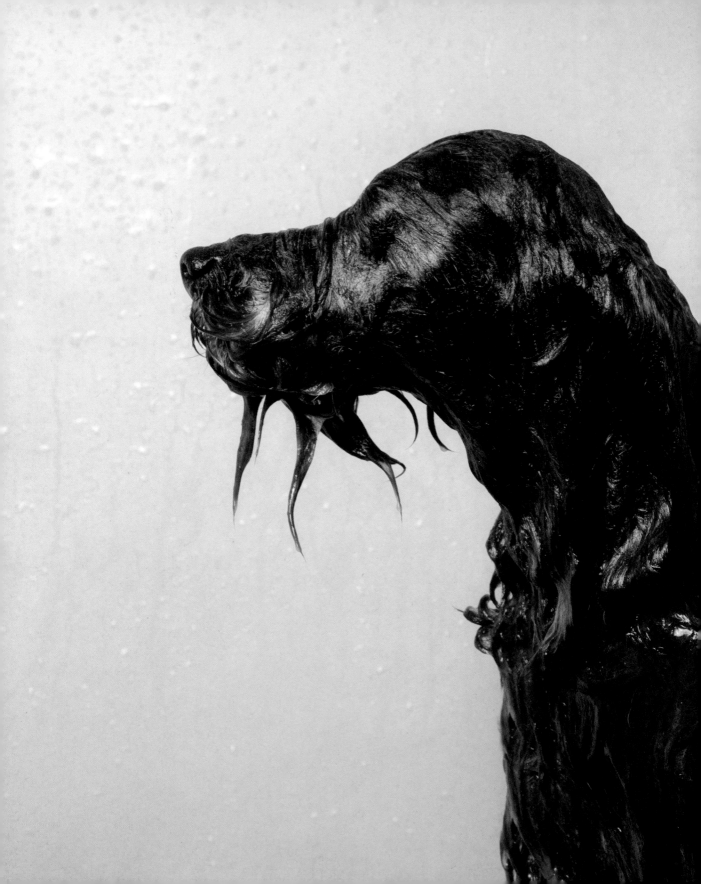

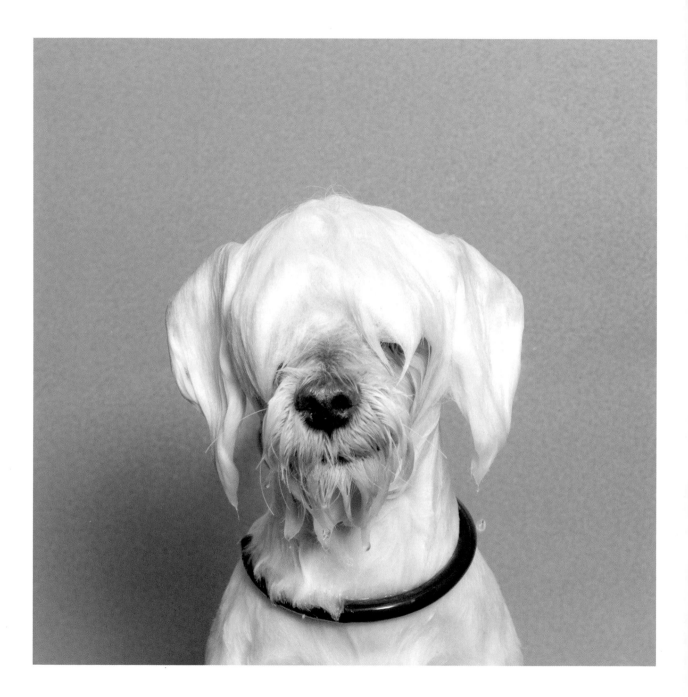

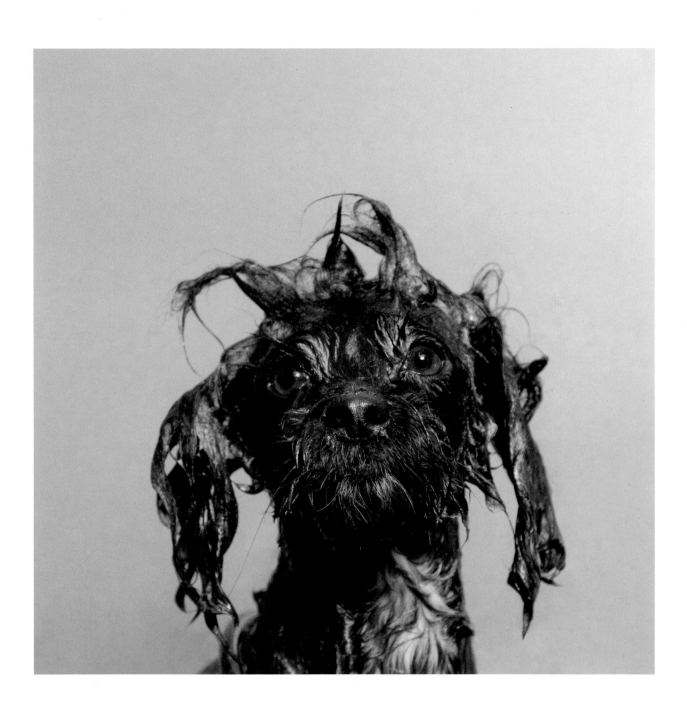

21

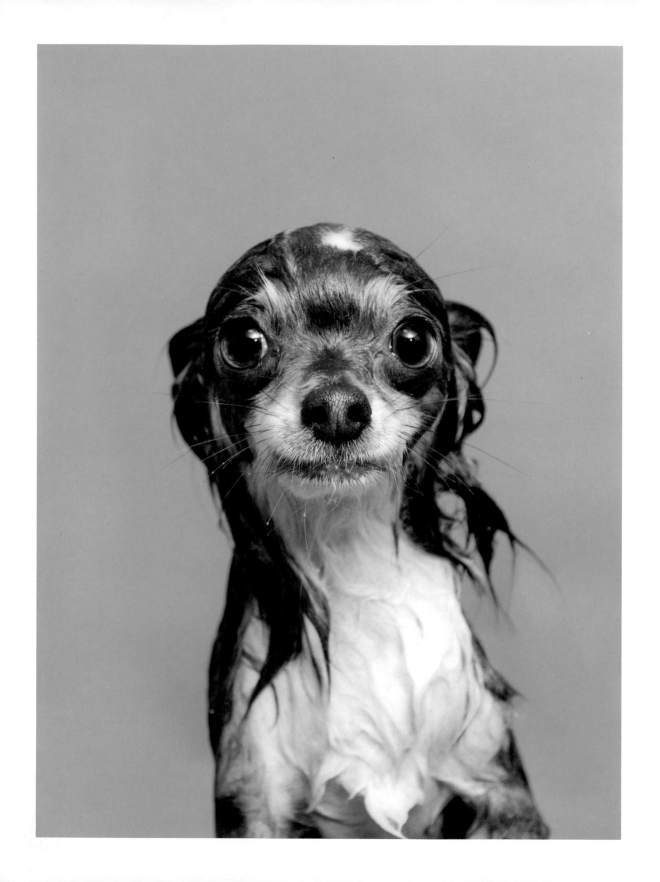

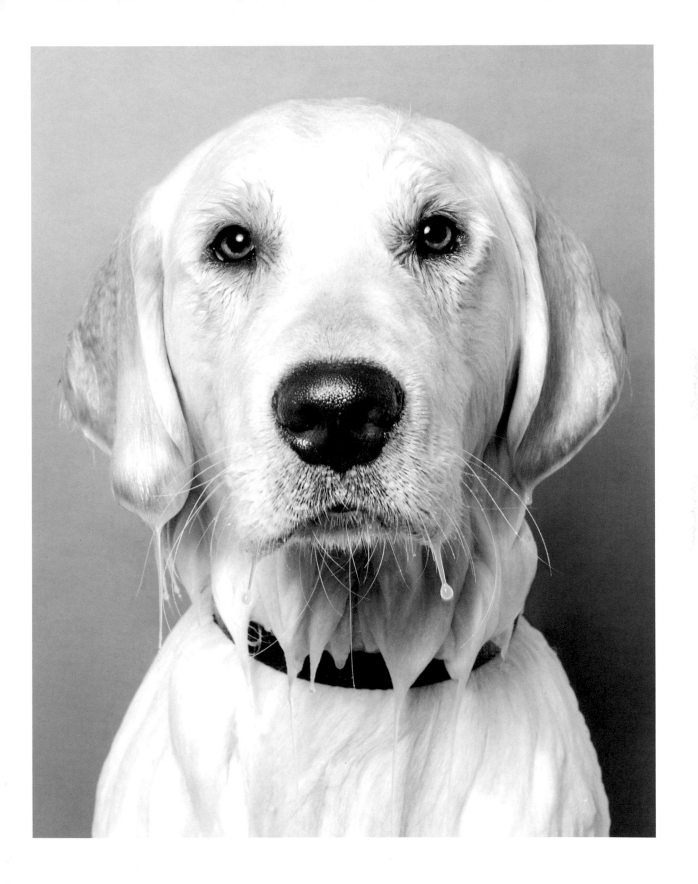

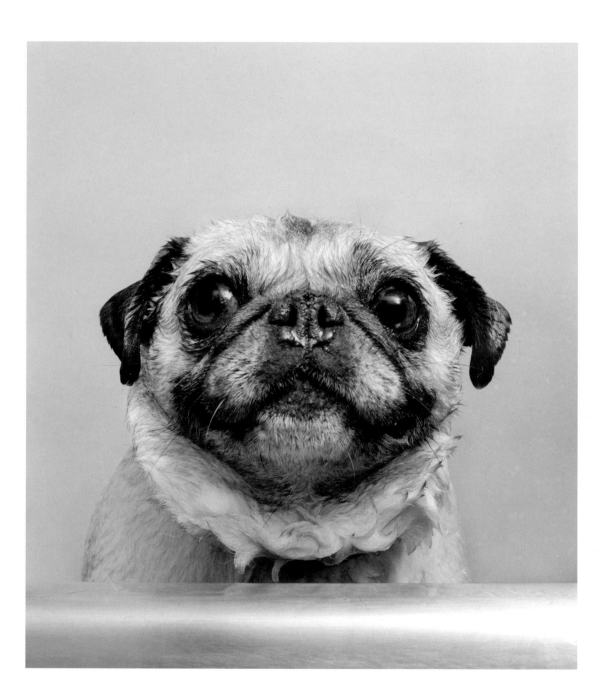

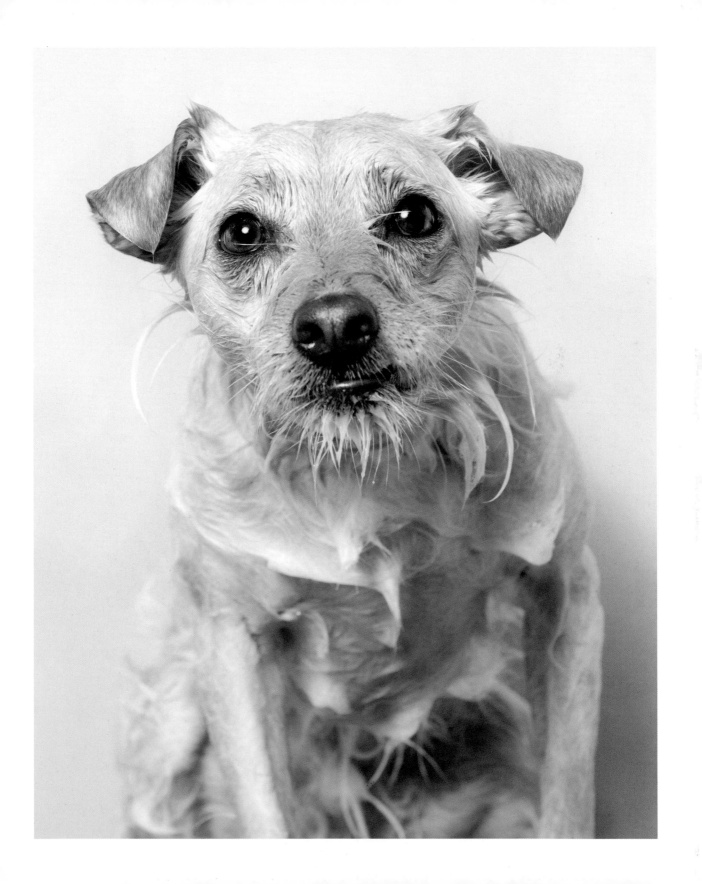

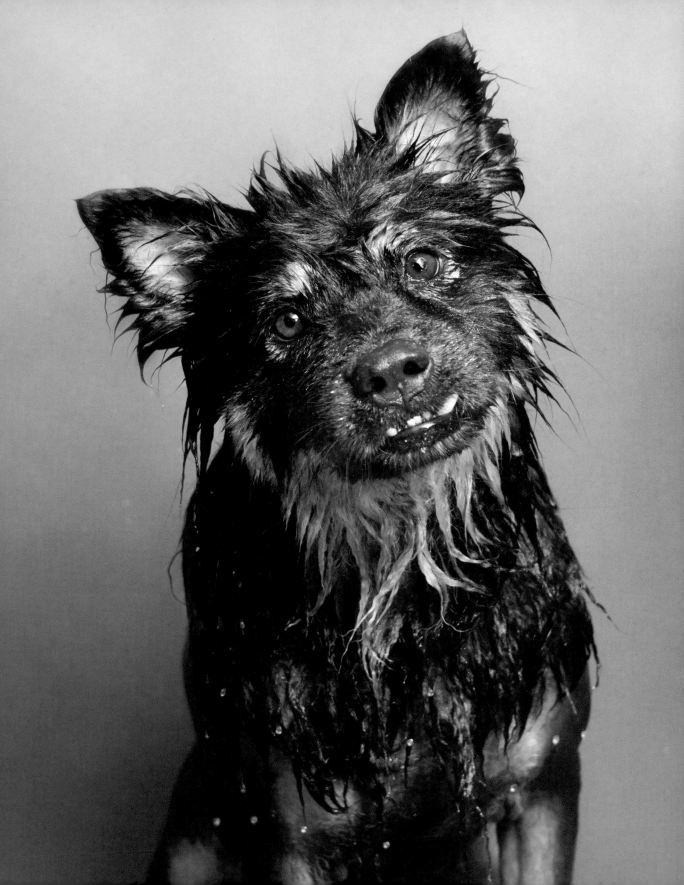

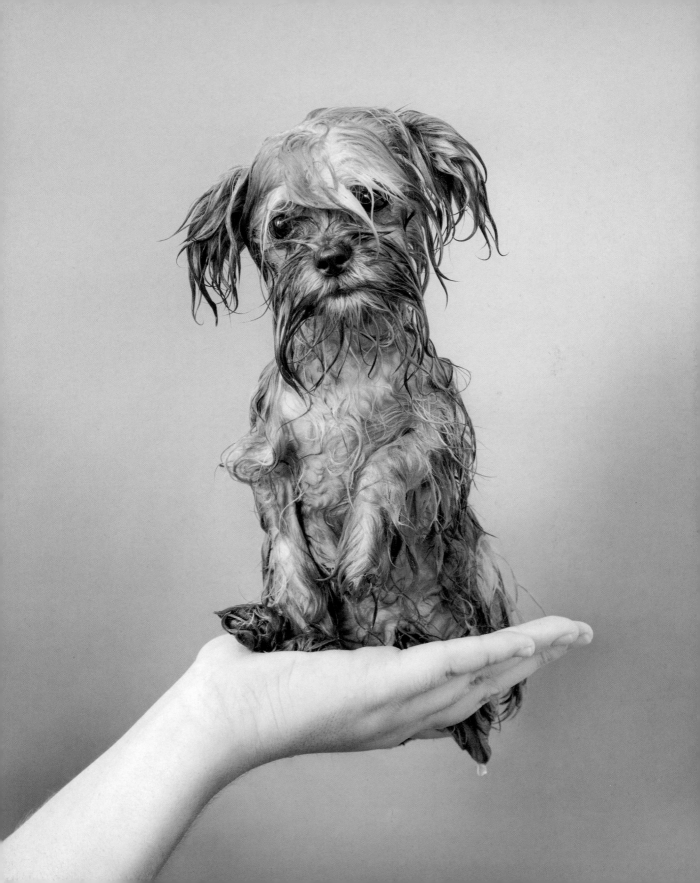

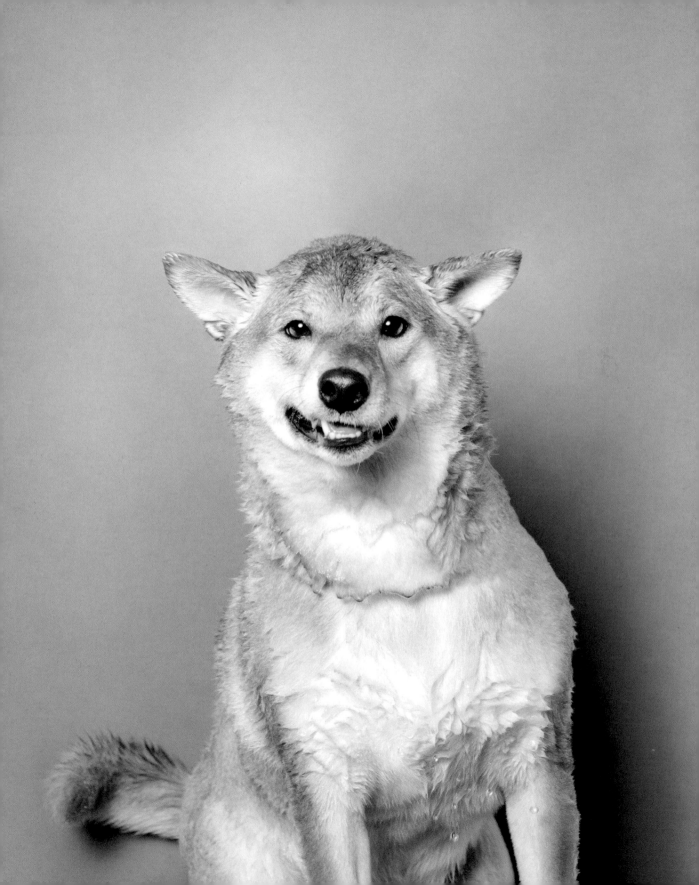

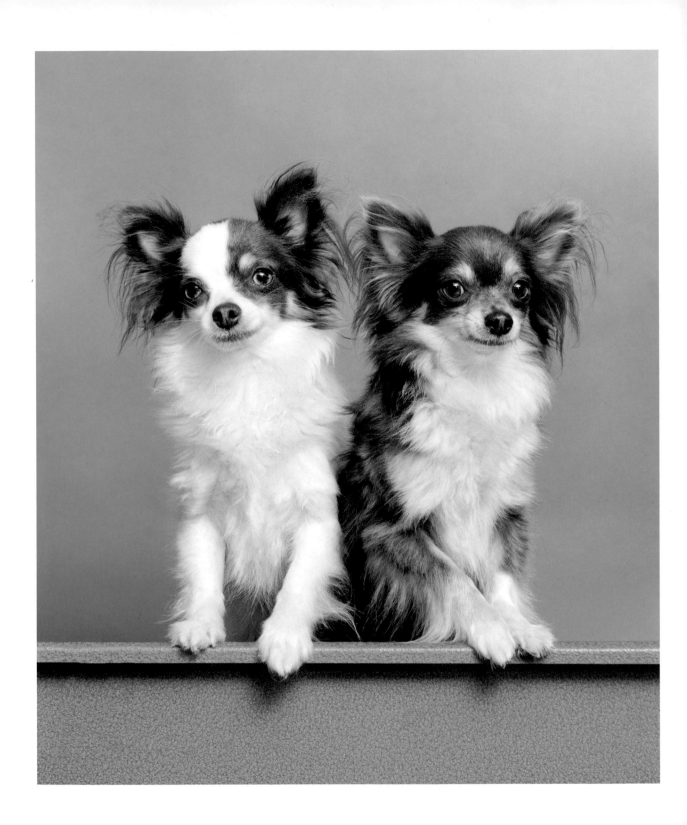

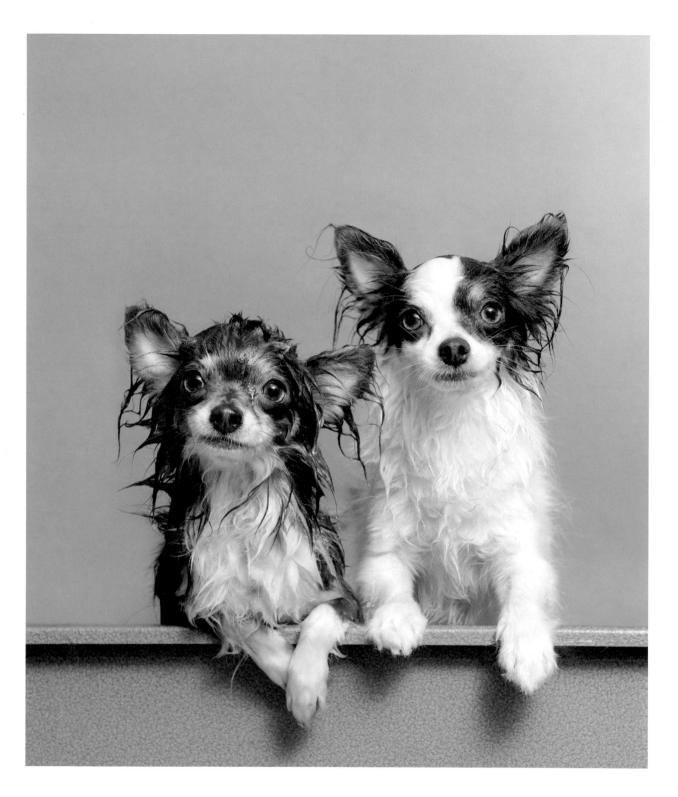

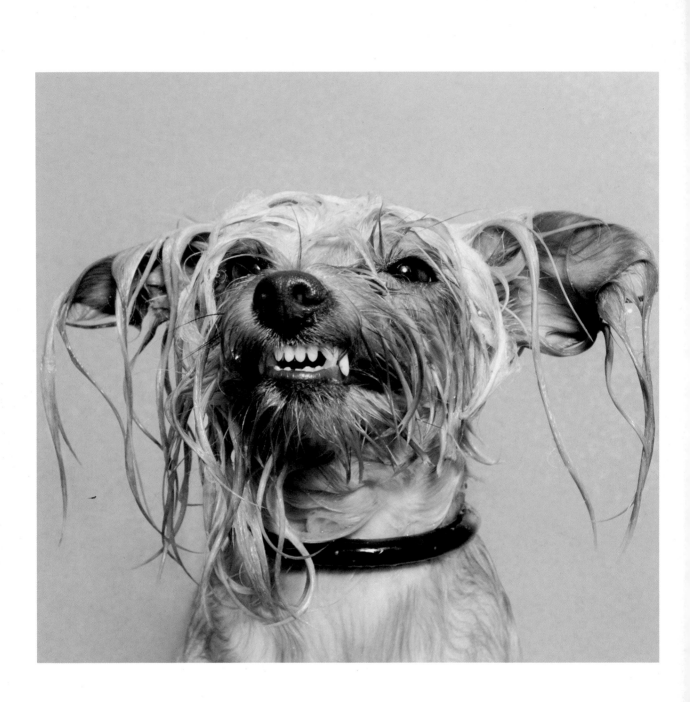

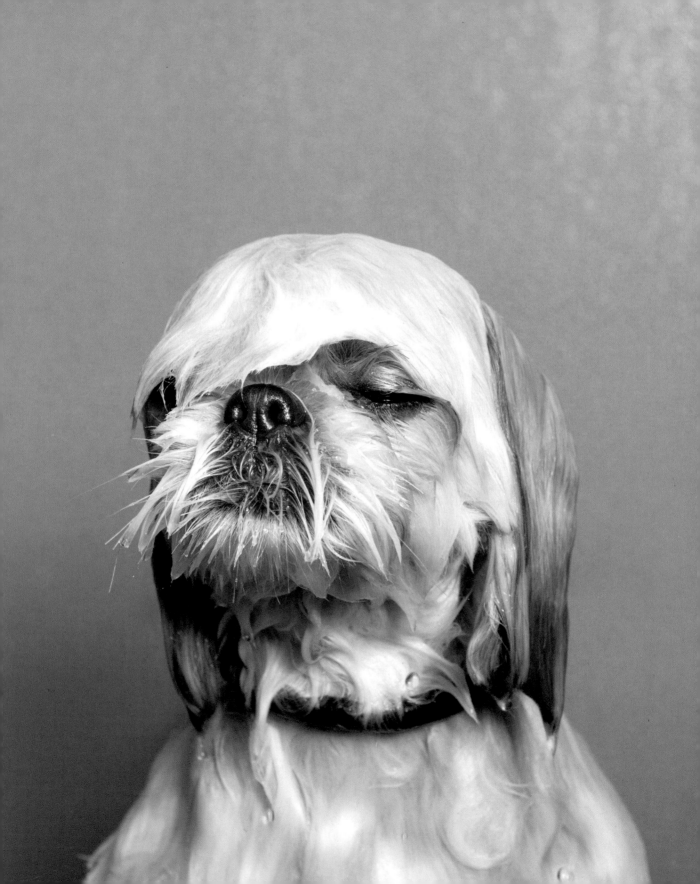

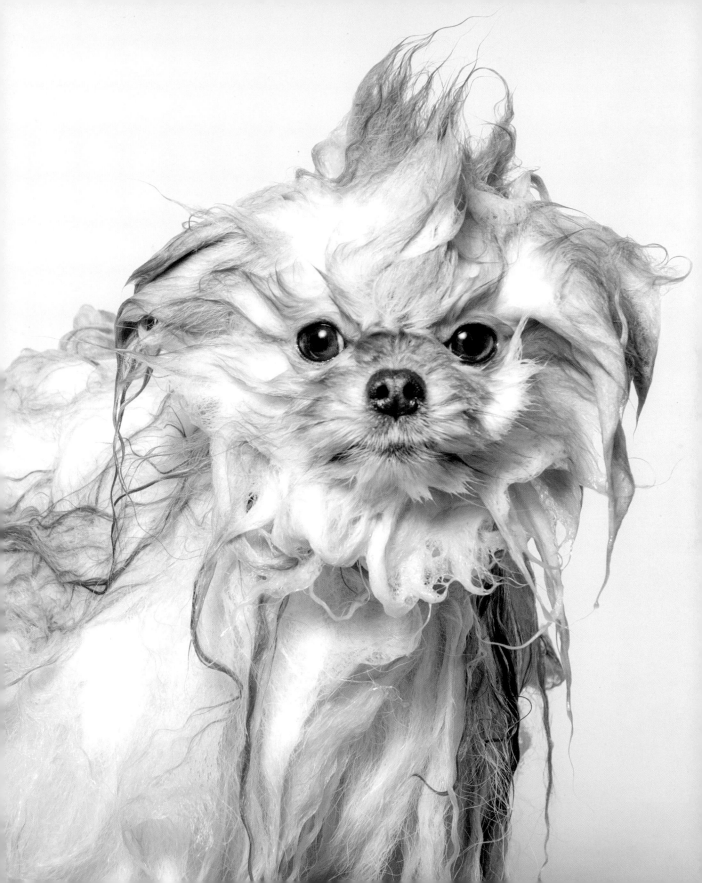

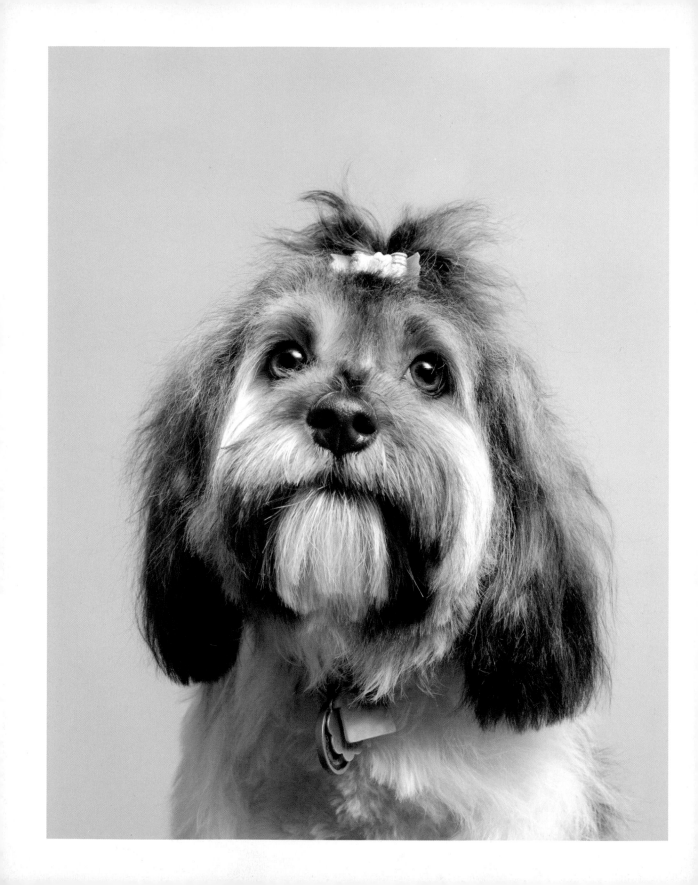

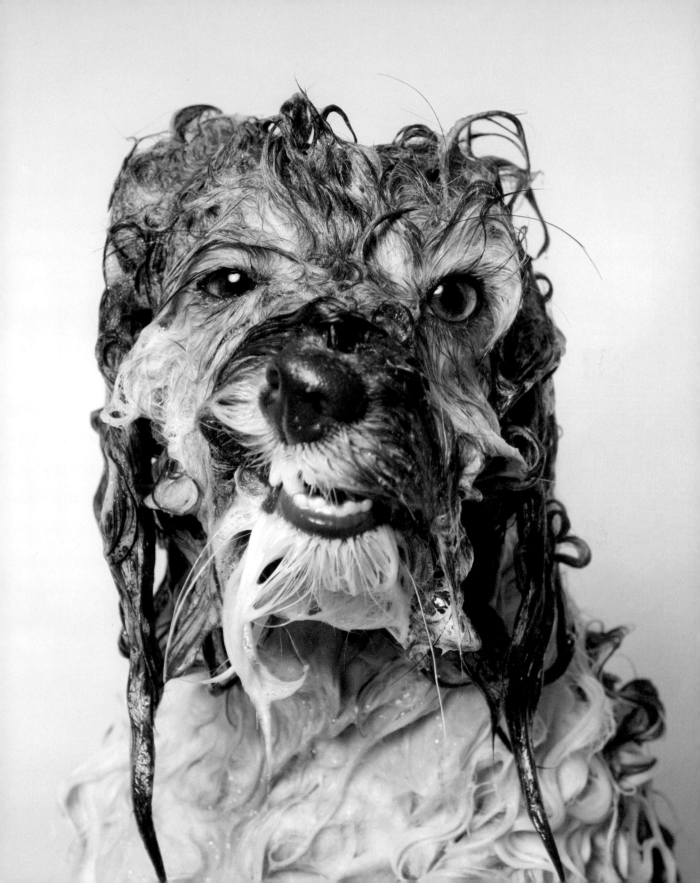

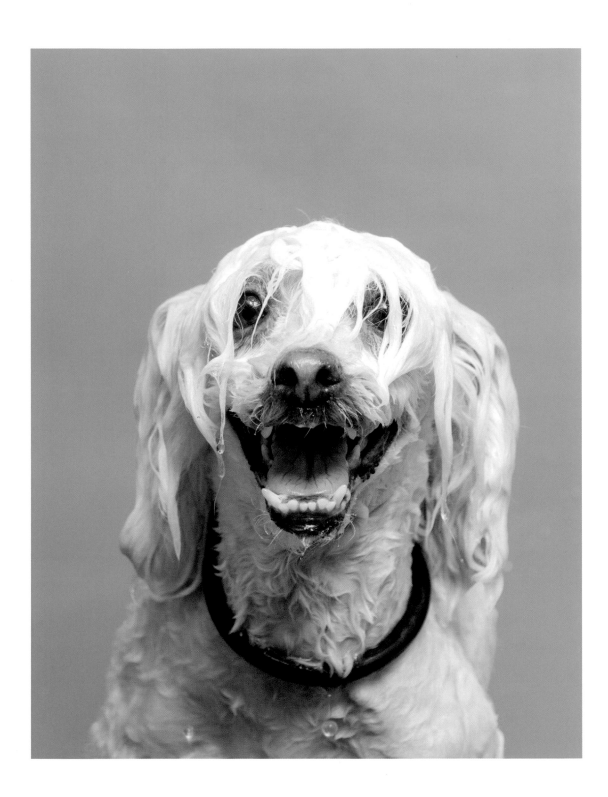

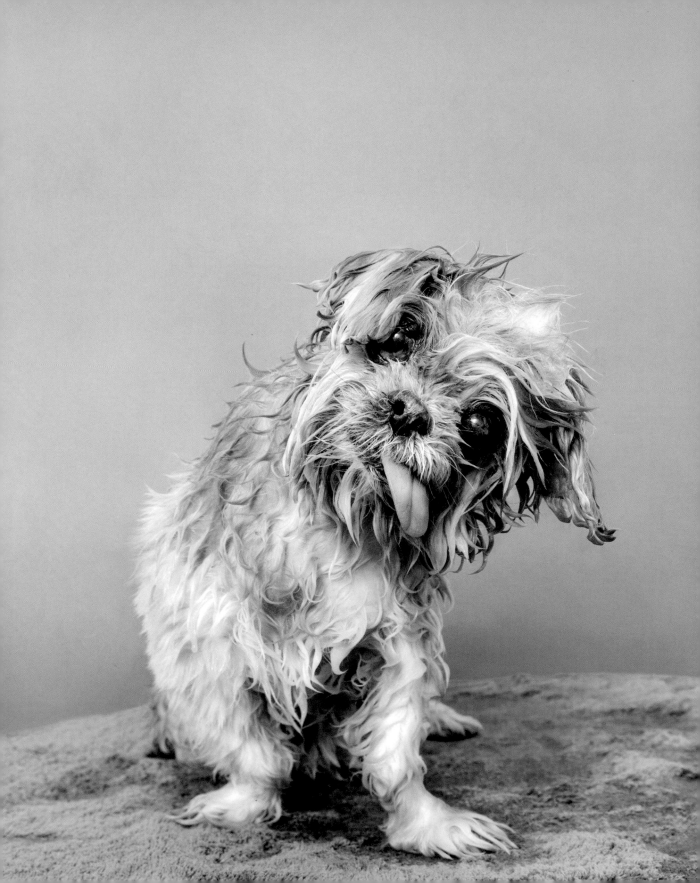

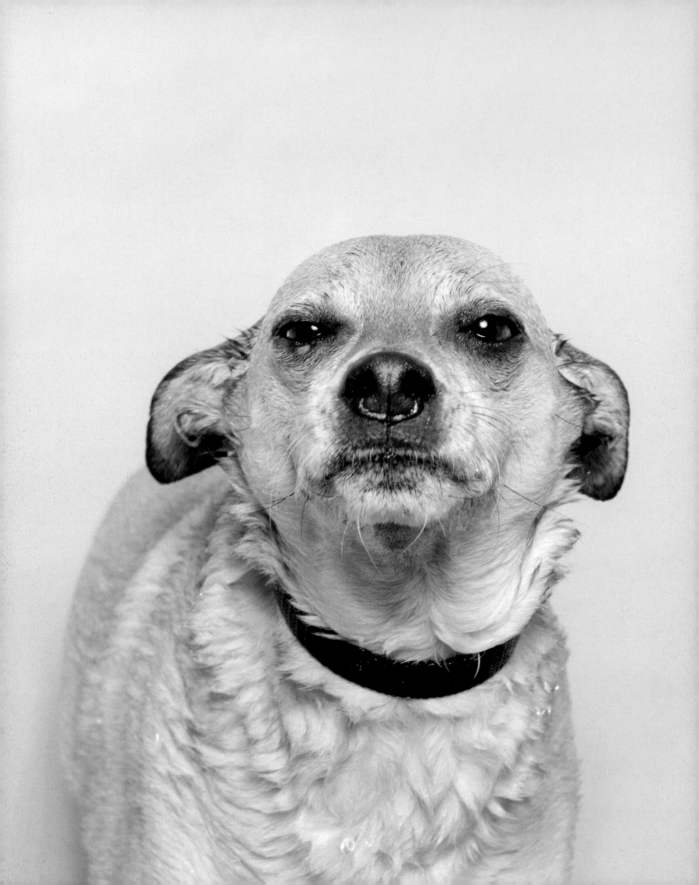

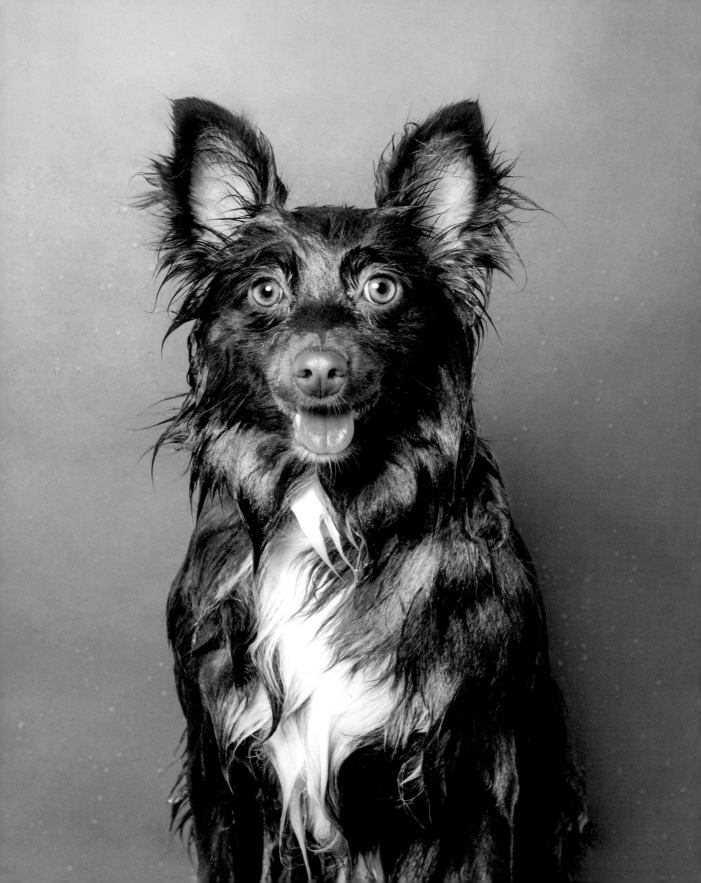

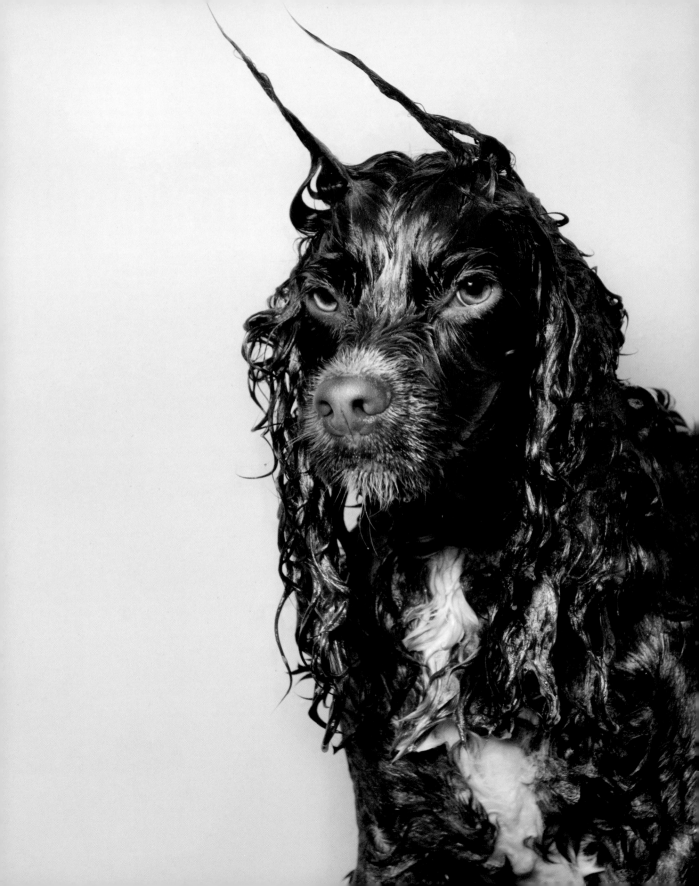

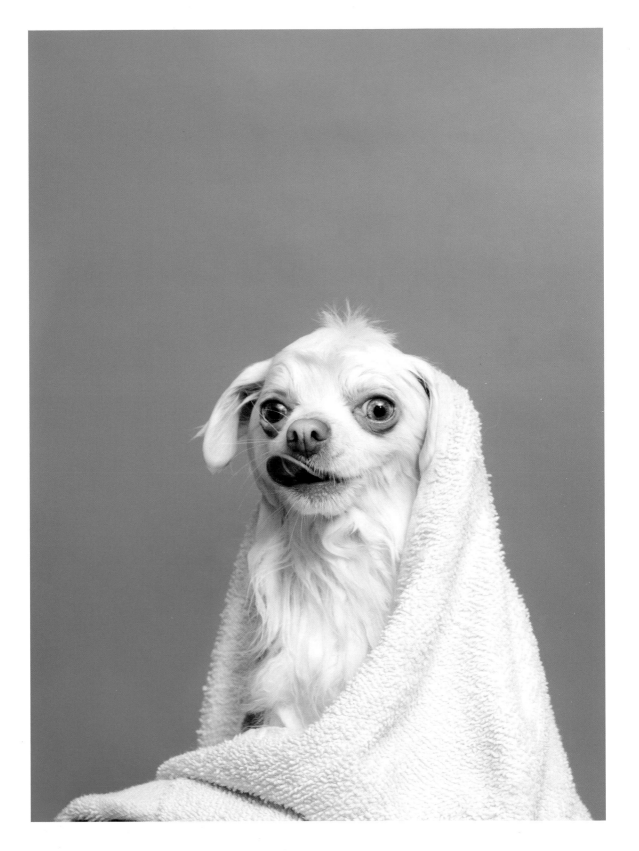

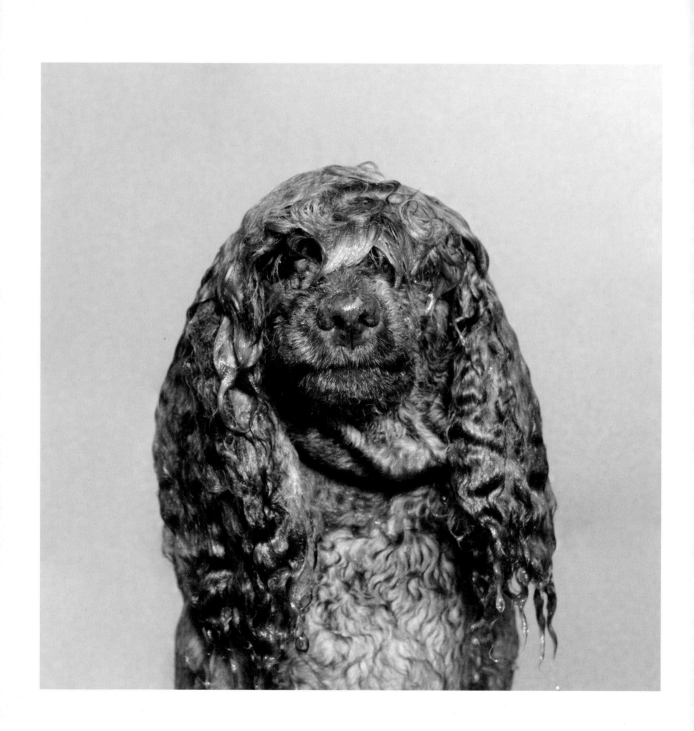

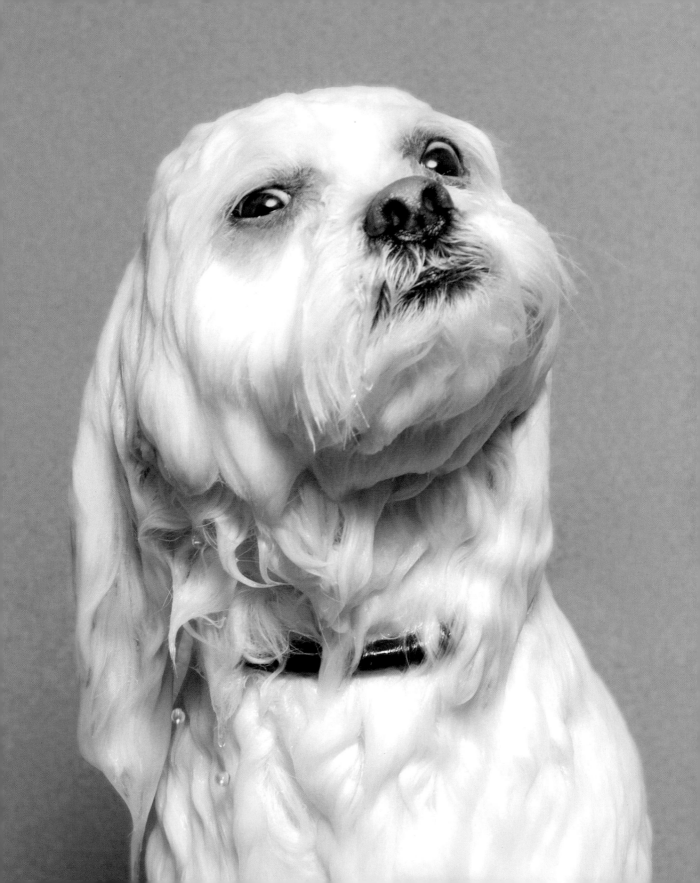

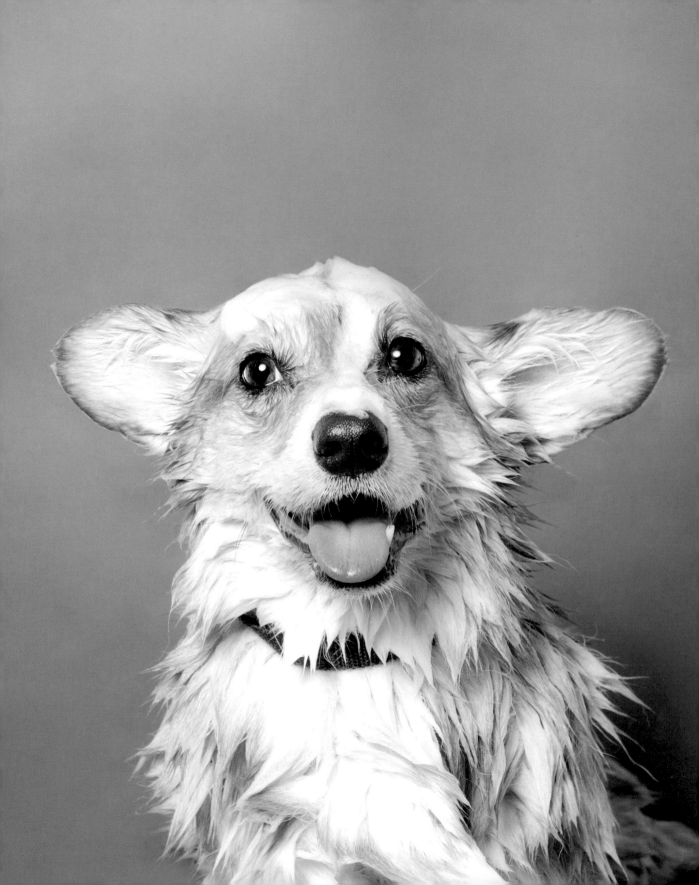

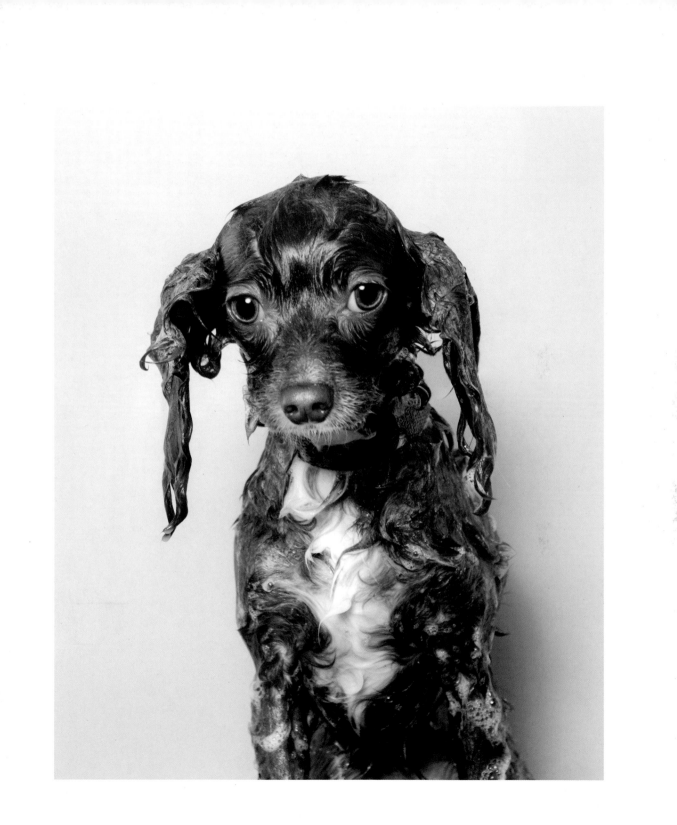

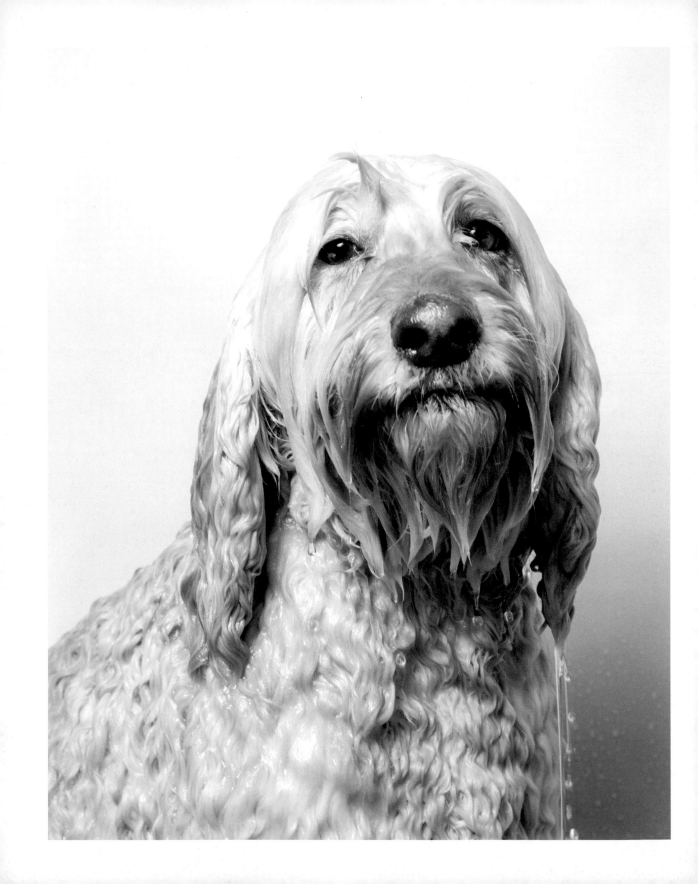

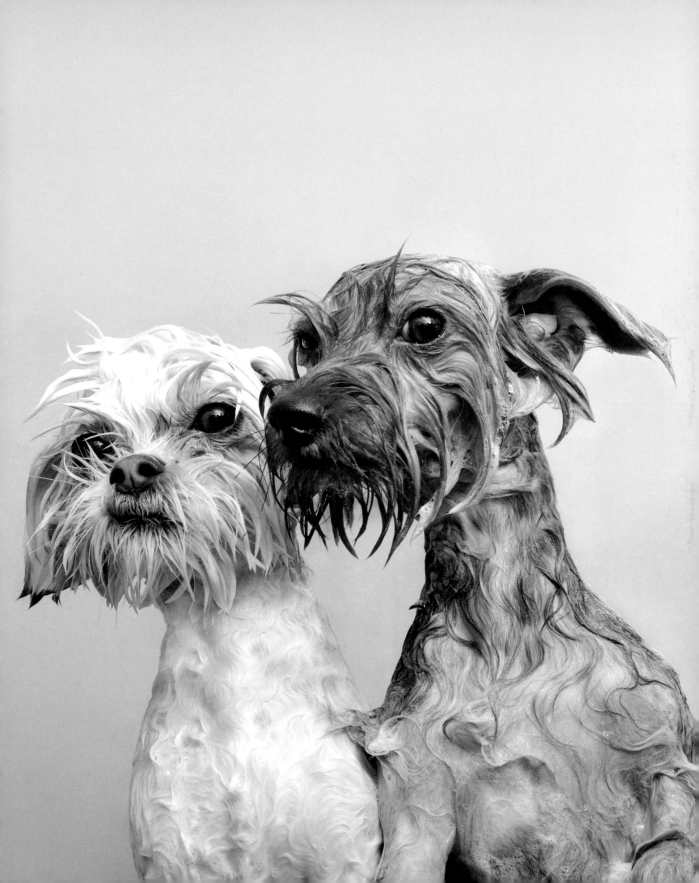

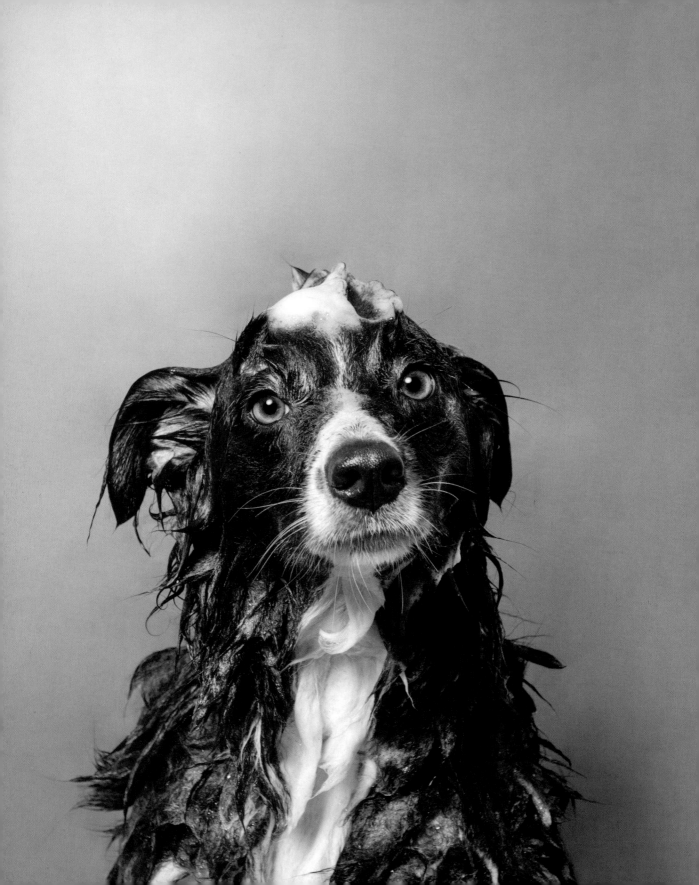

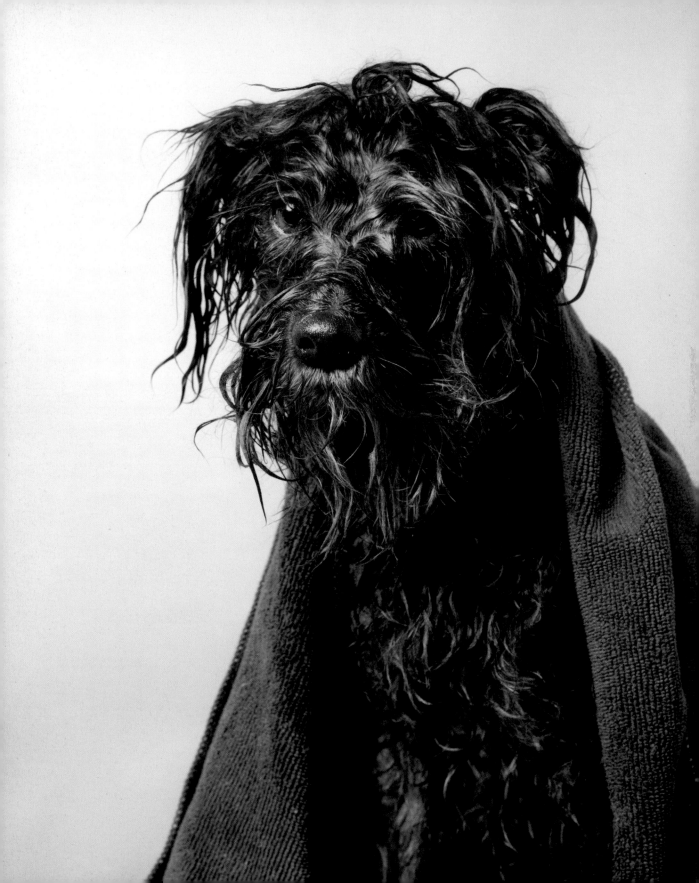

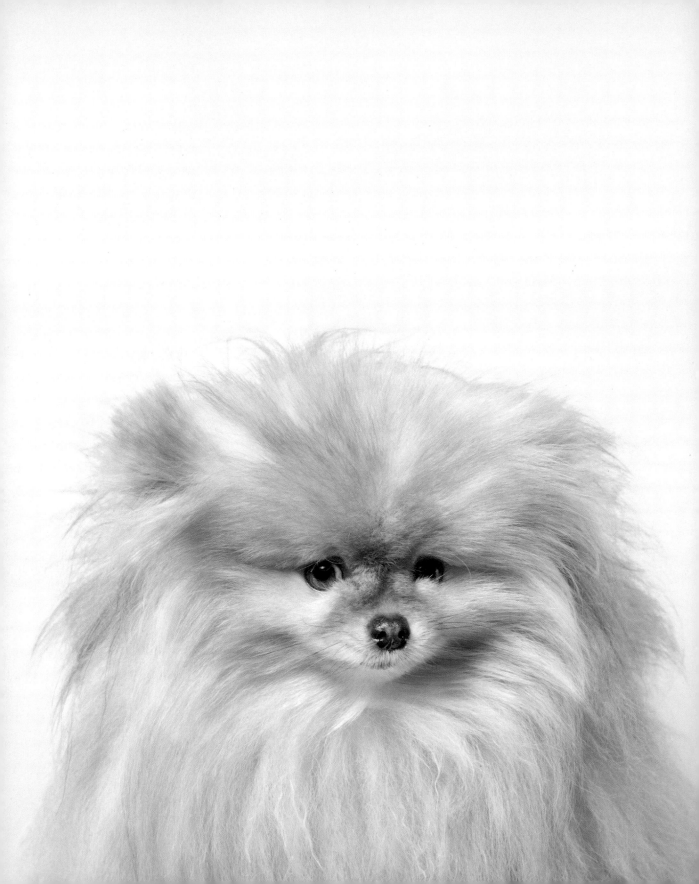

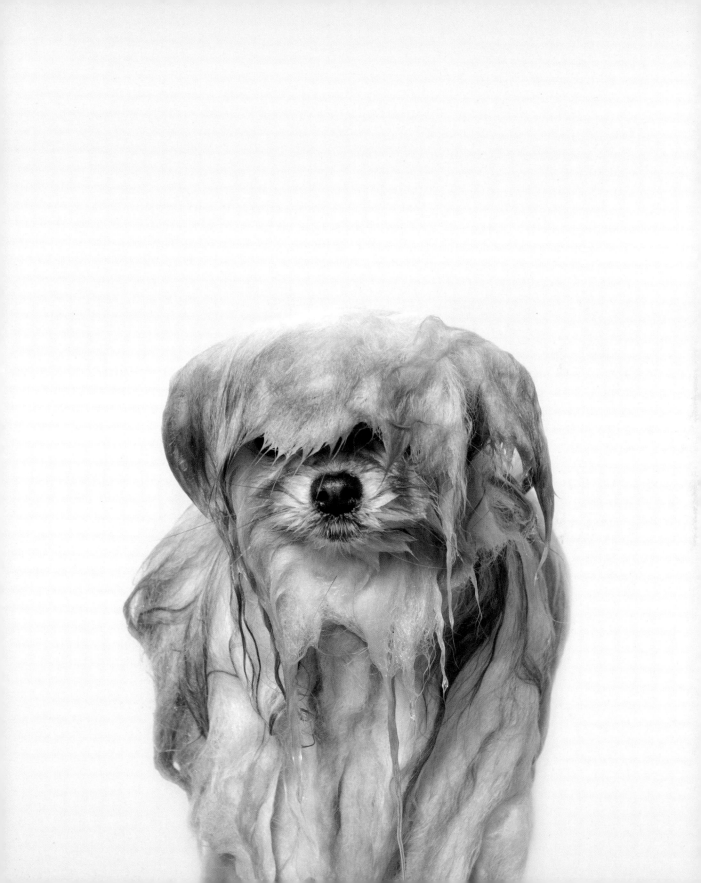

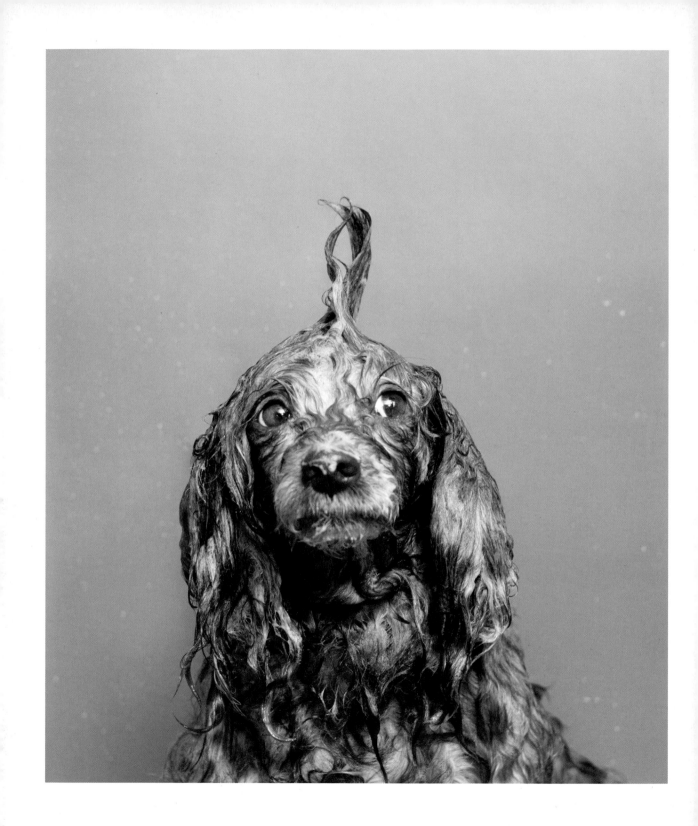

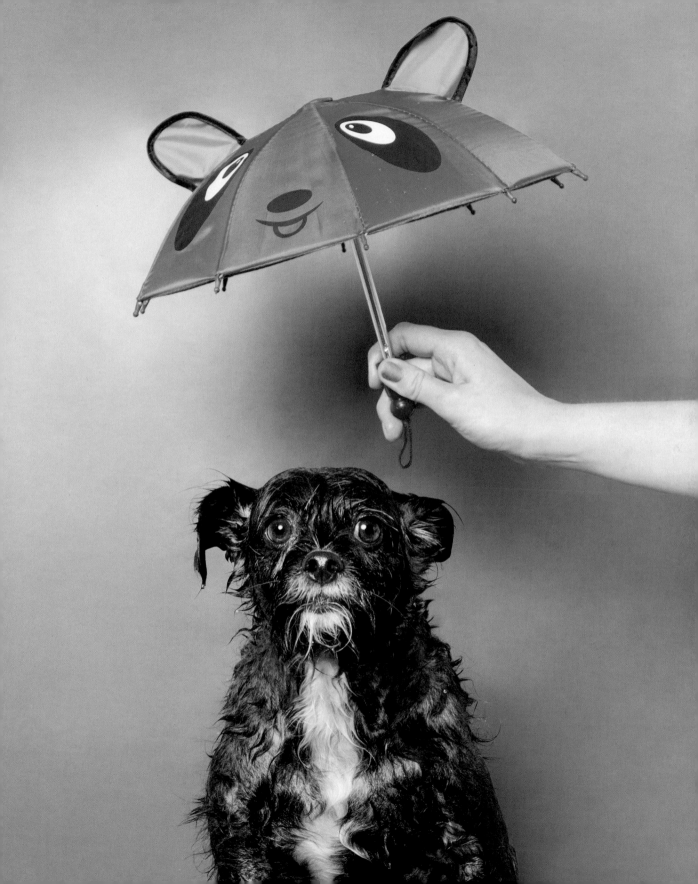

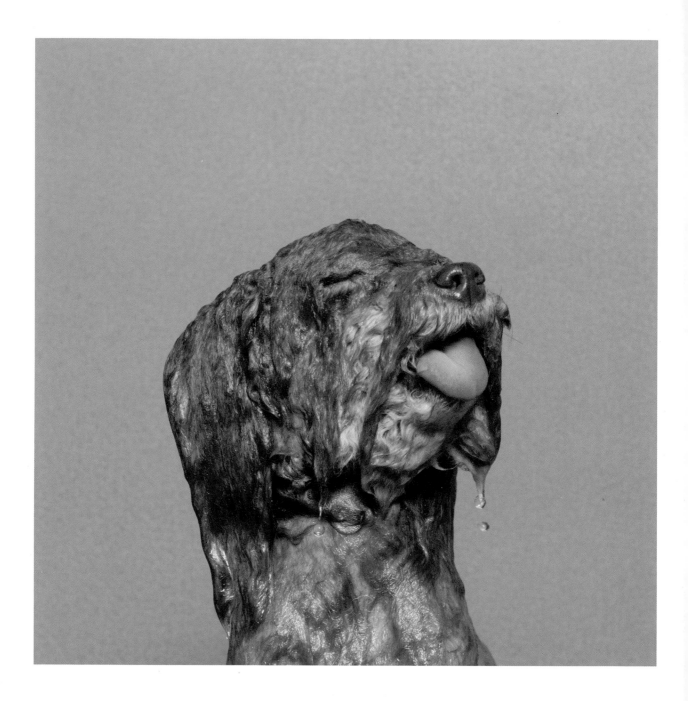

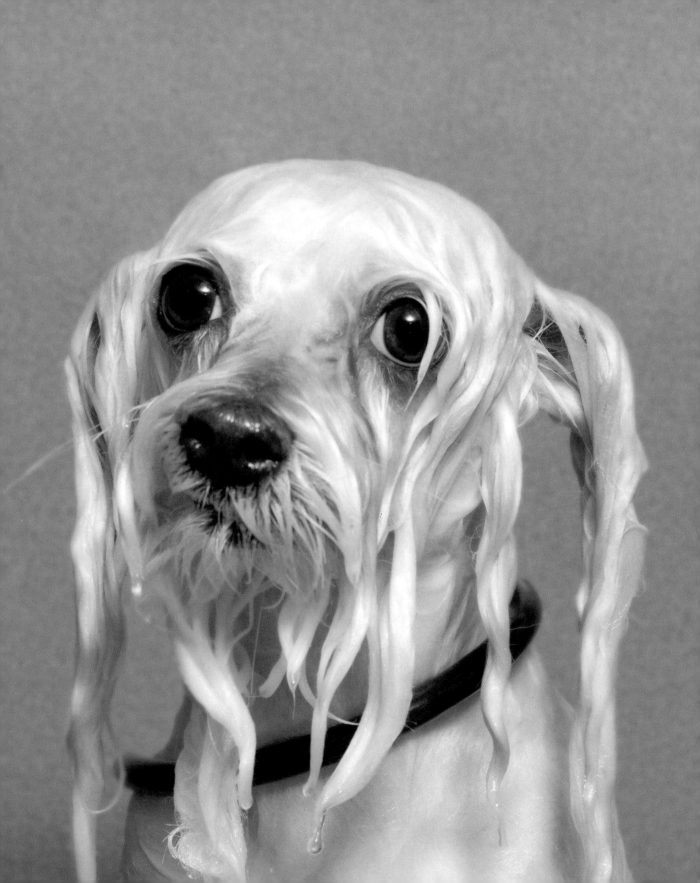

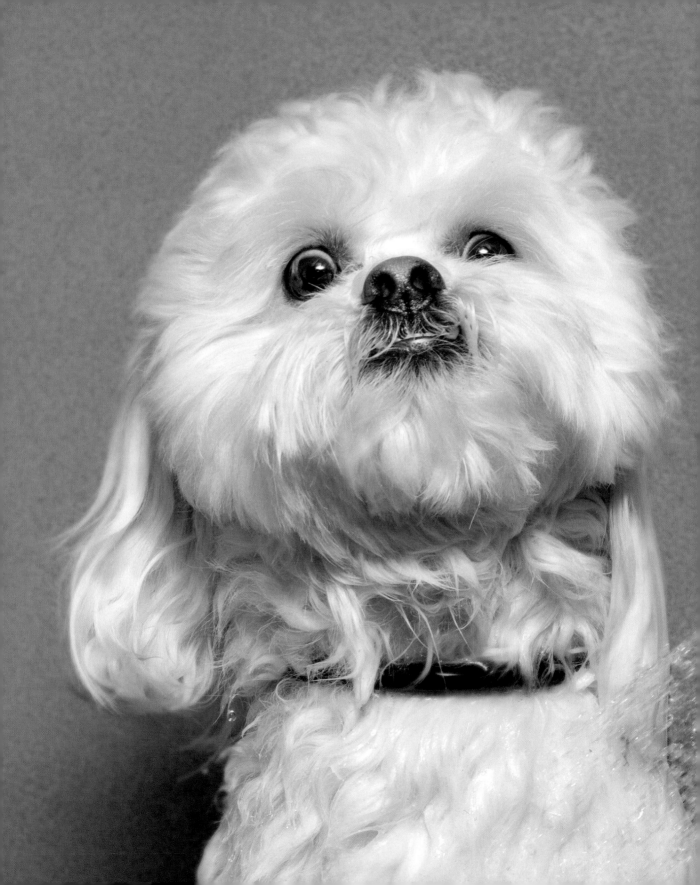

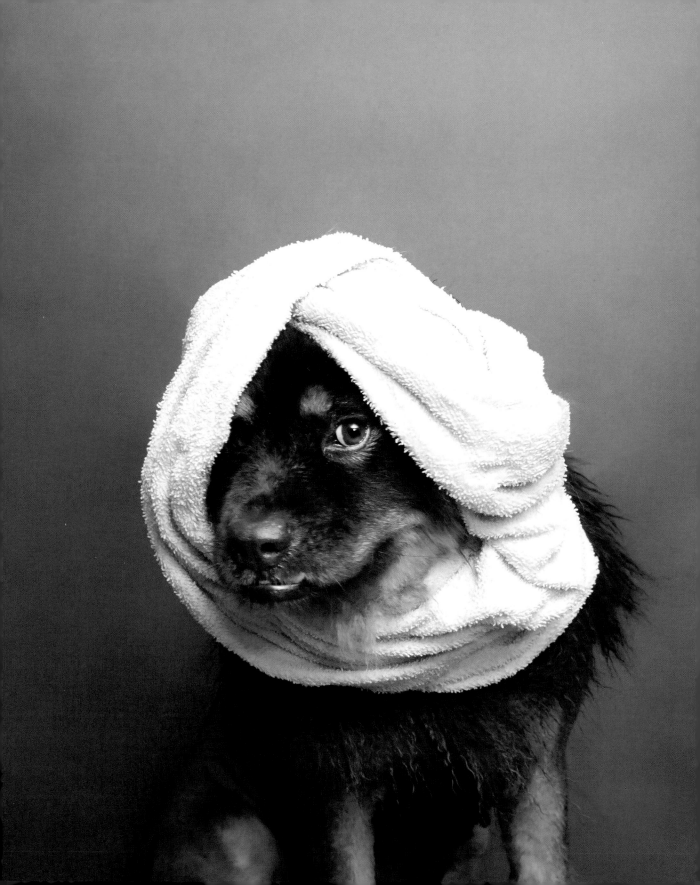

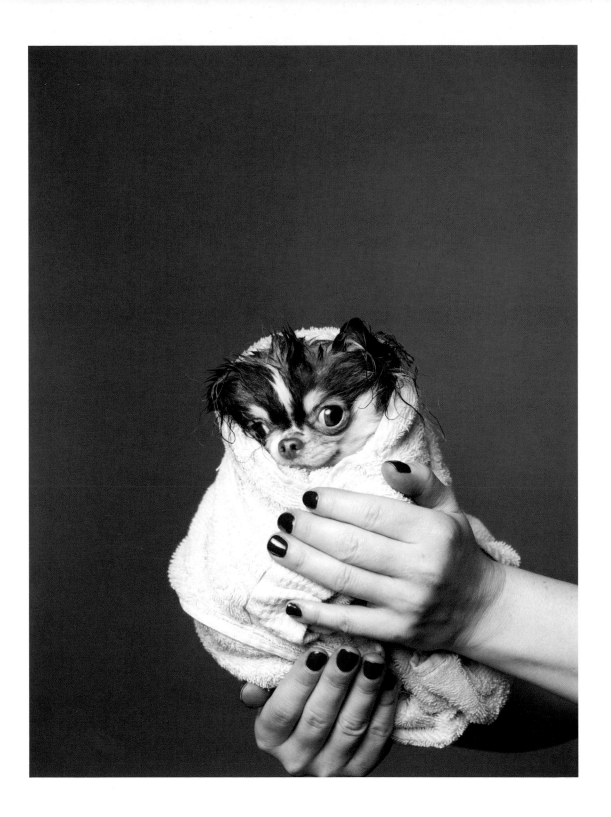

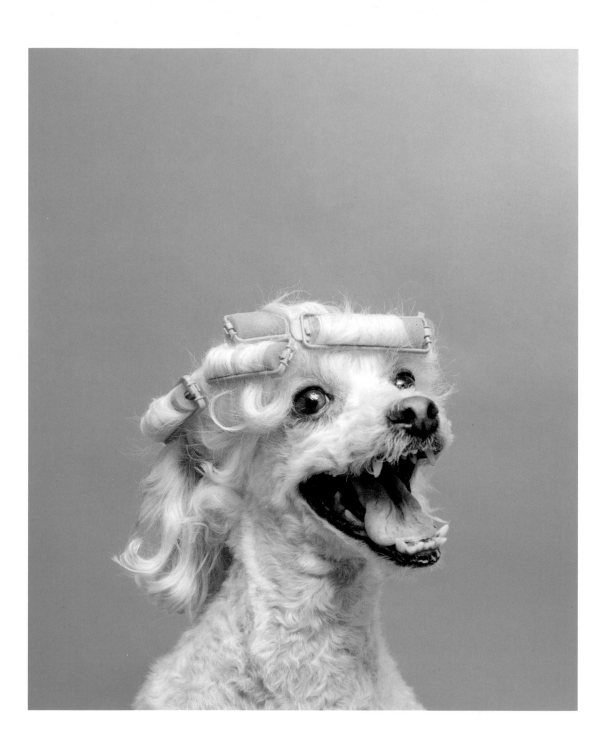

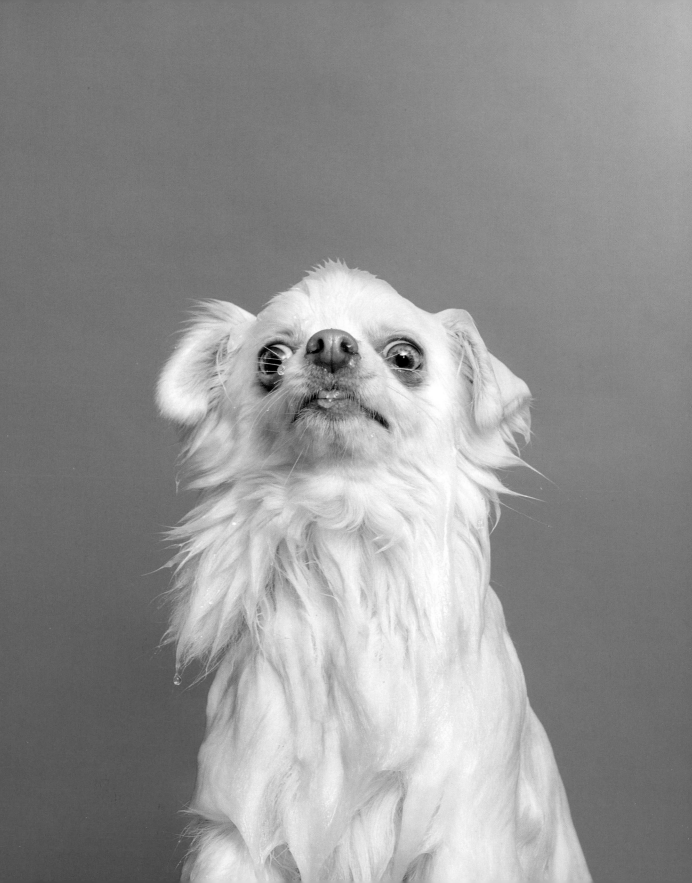

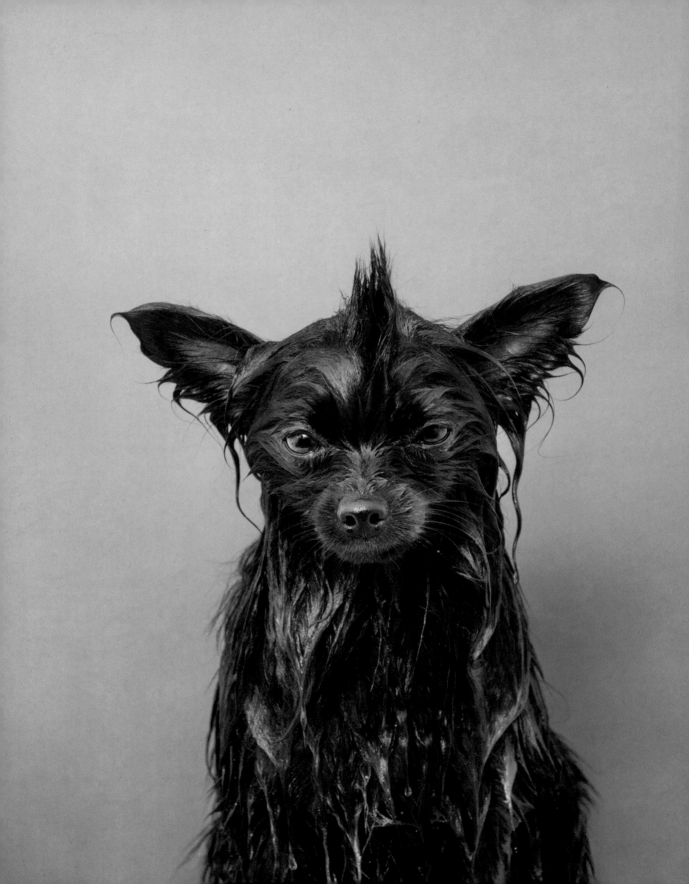

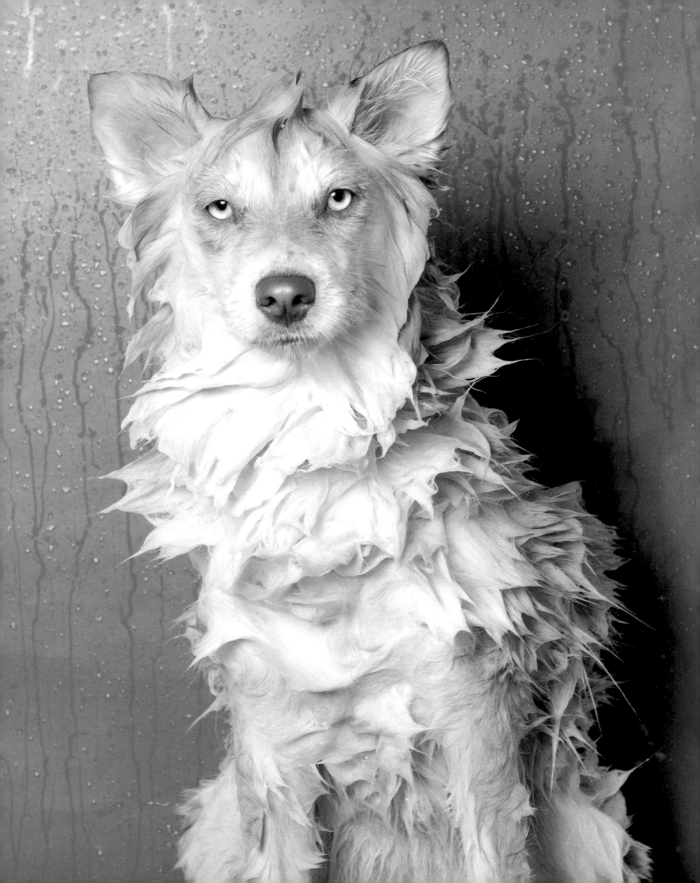

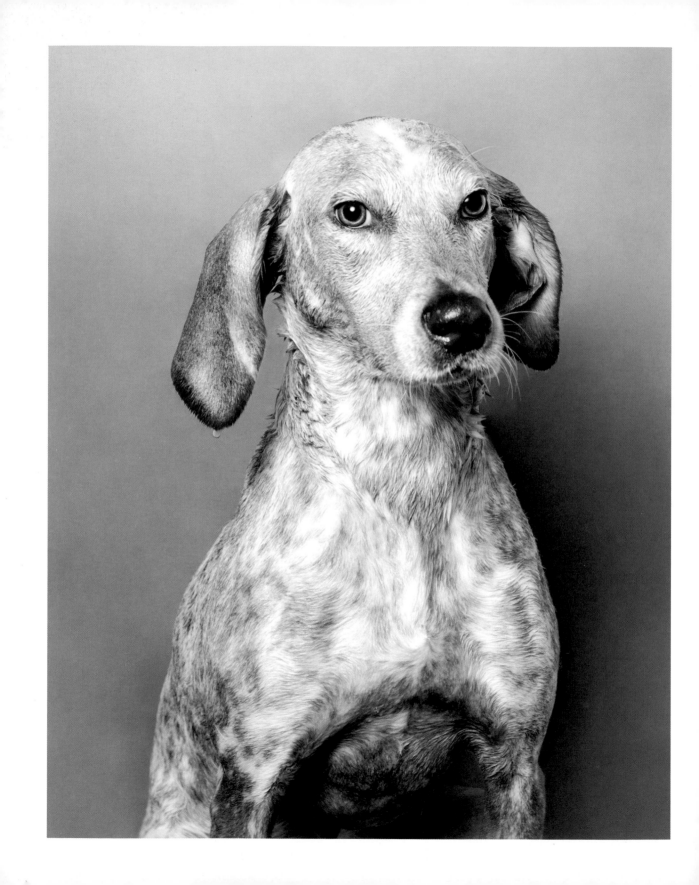

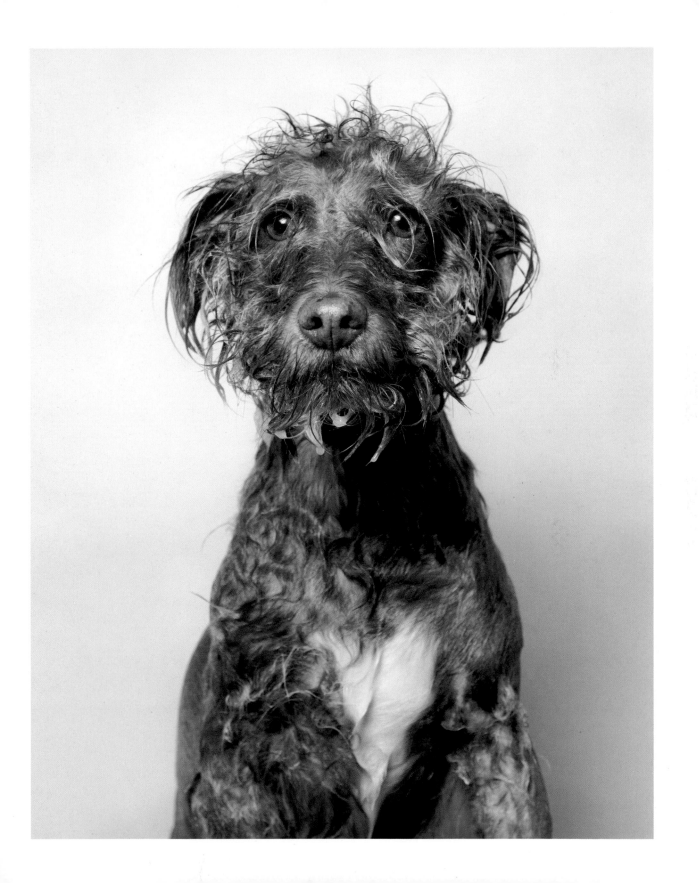

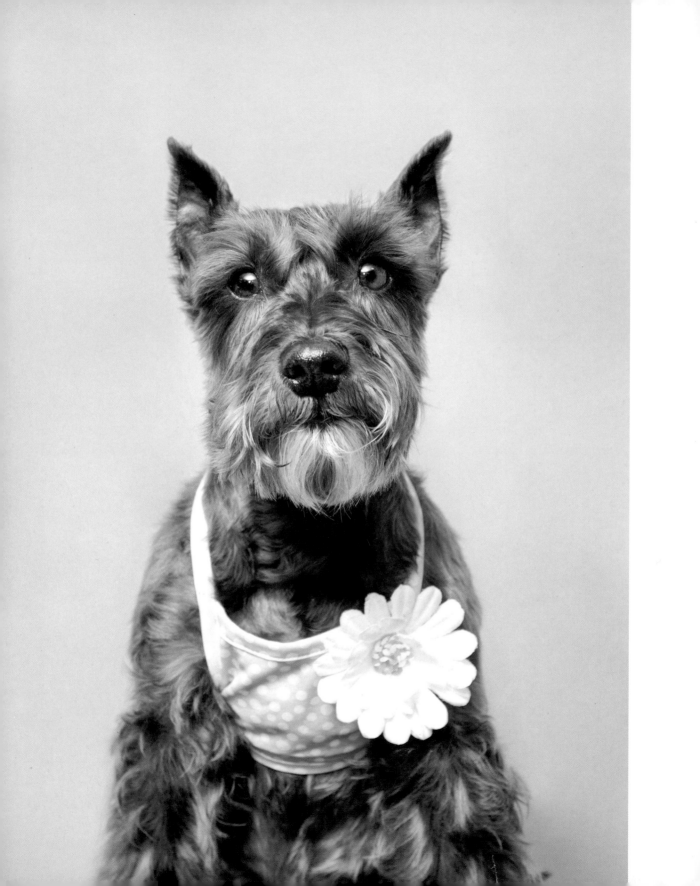

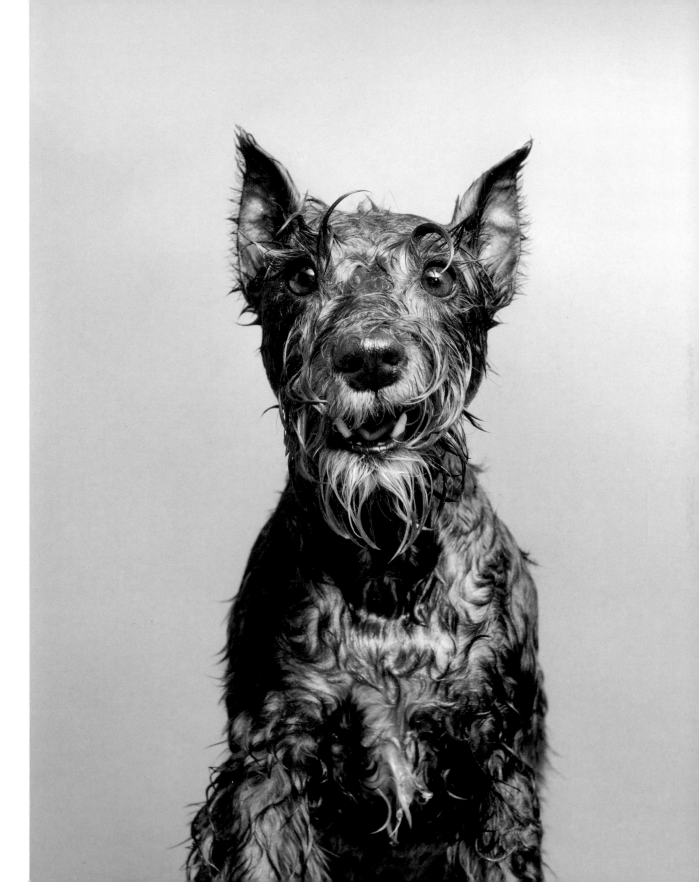

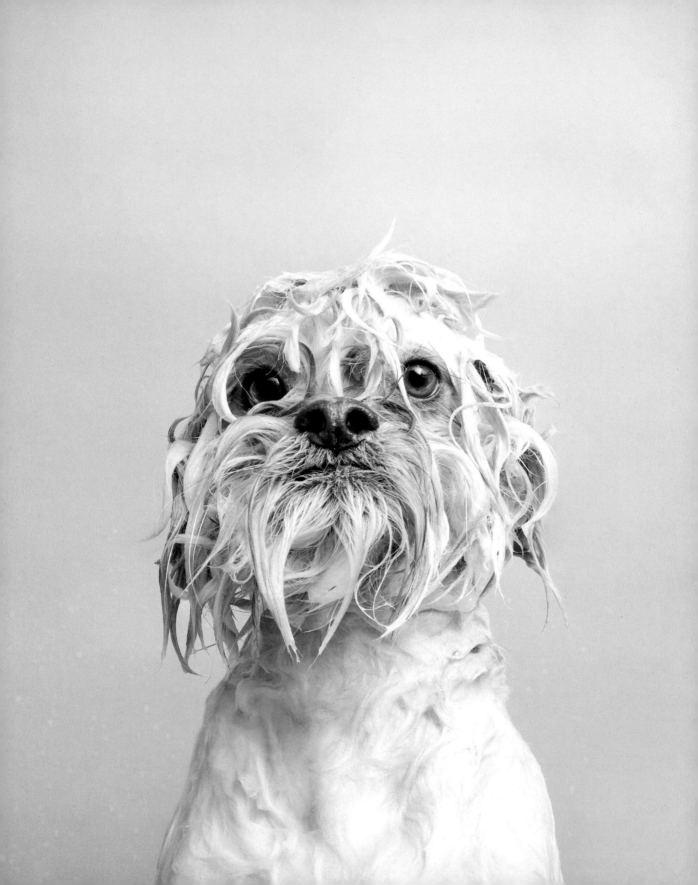

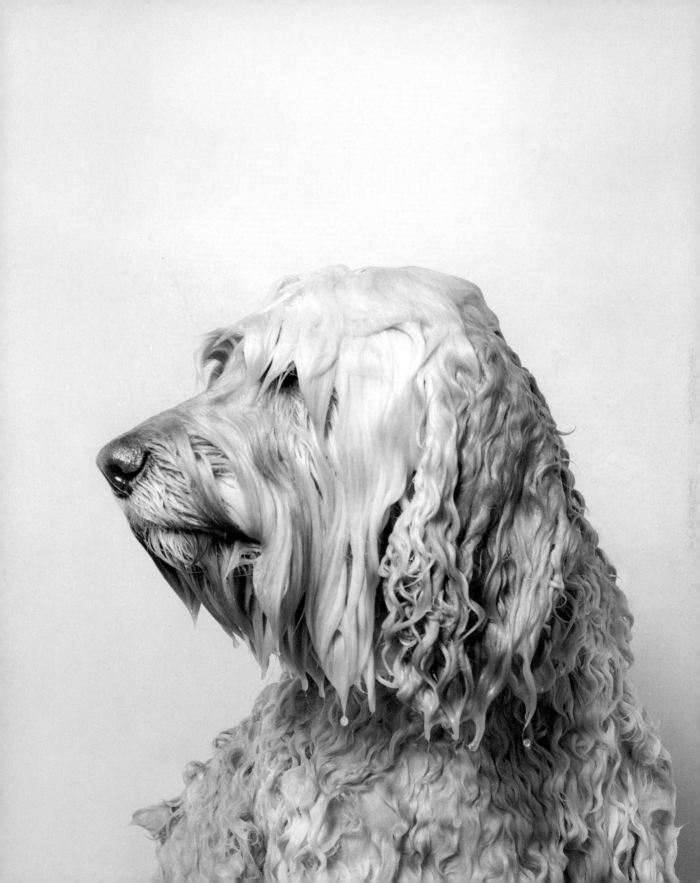

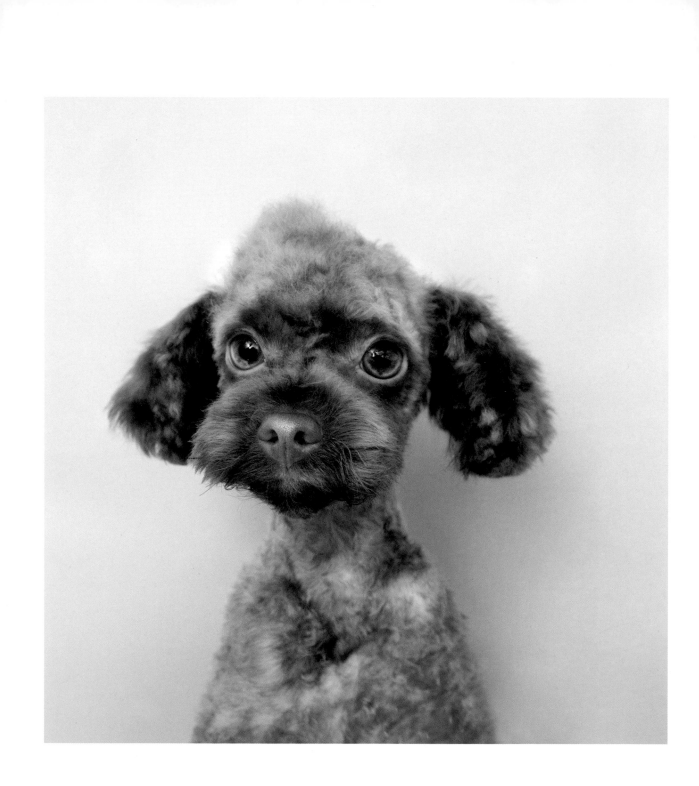

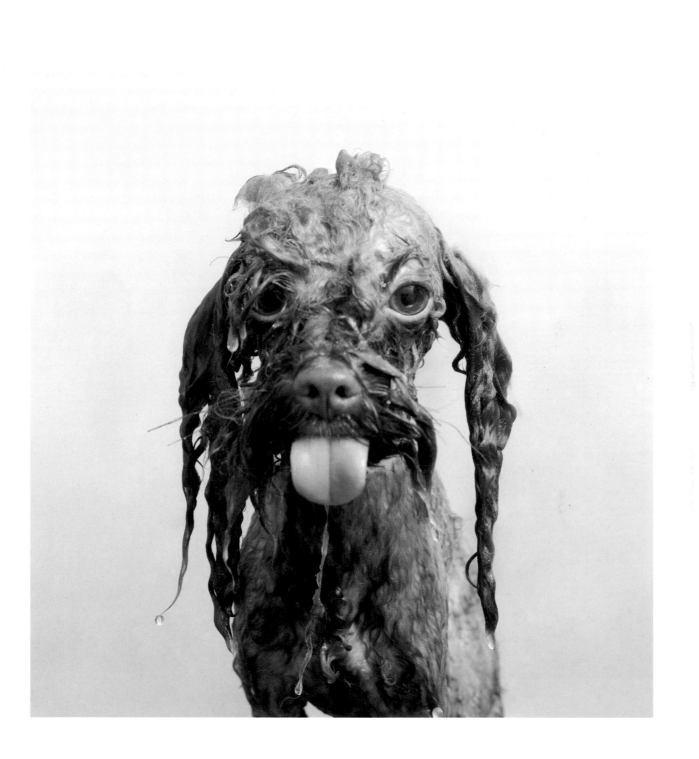

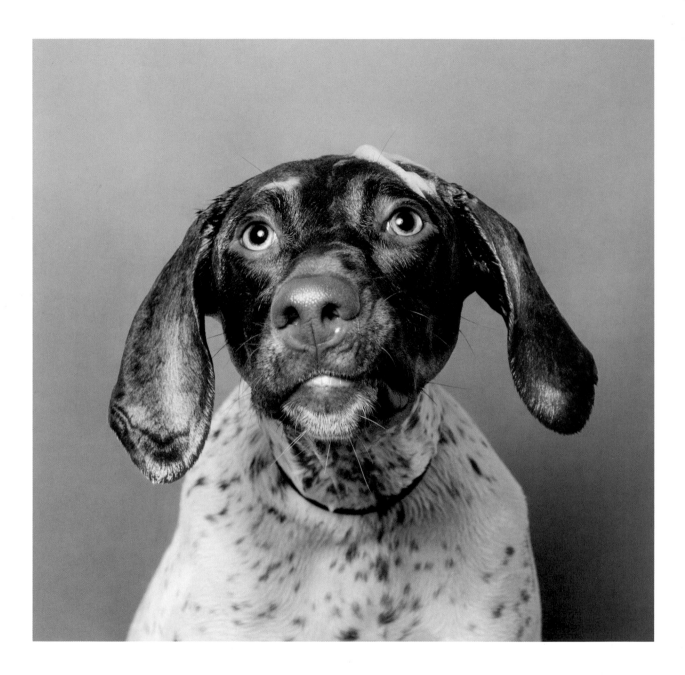

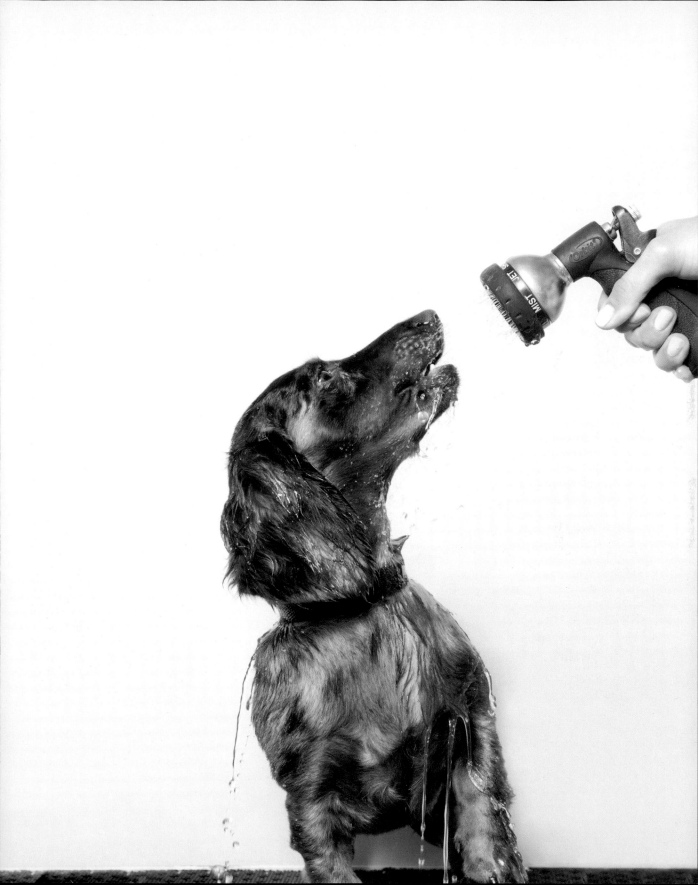

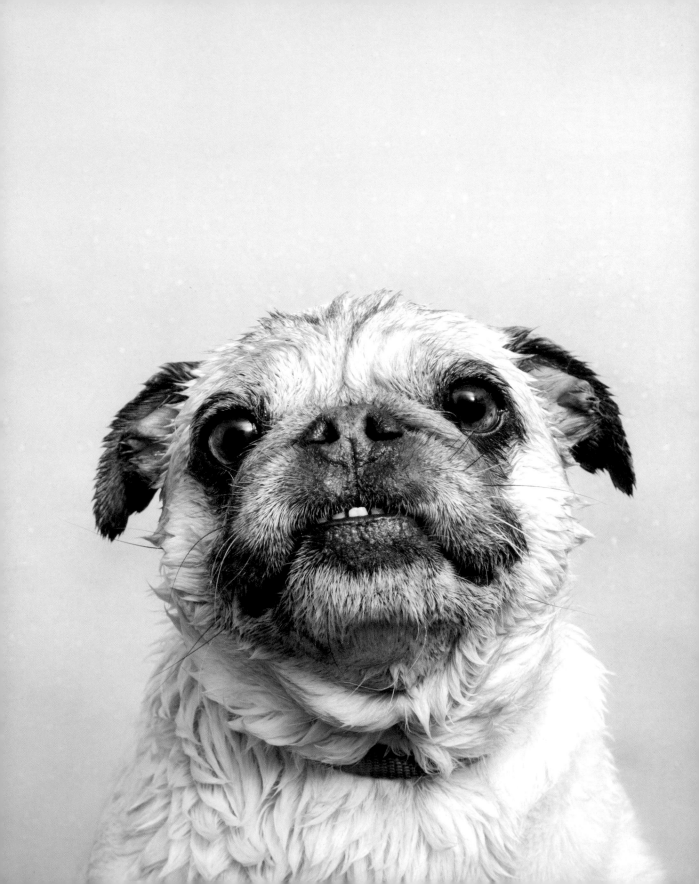

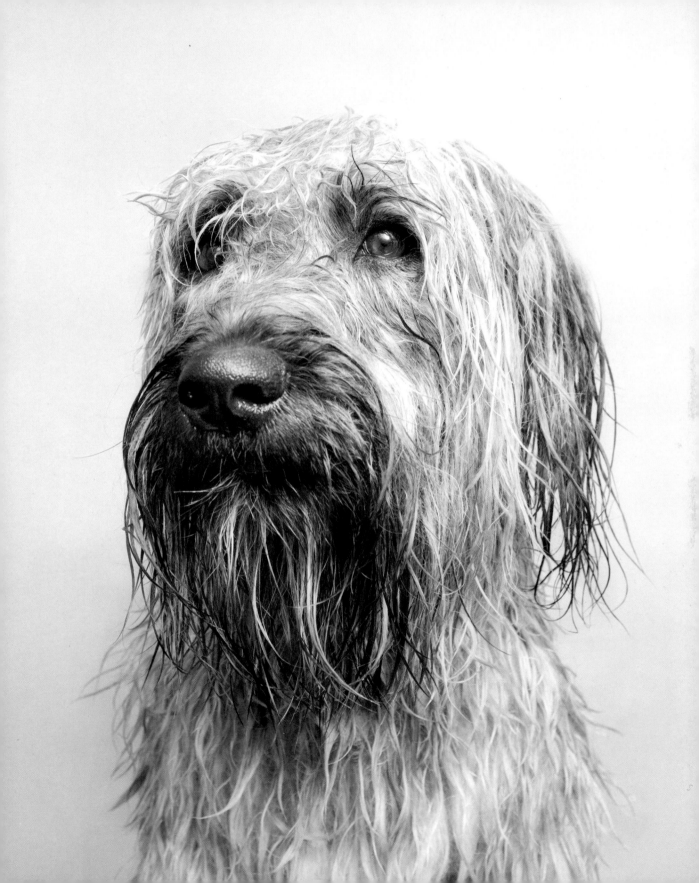

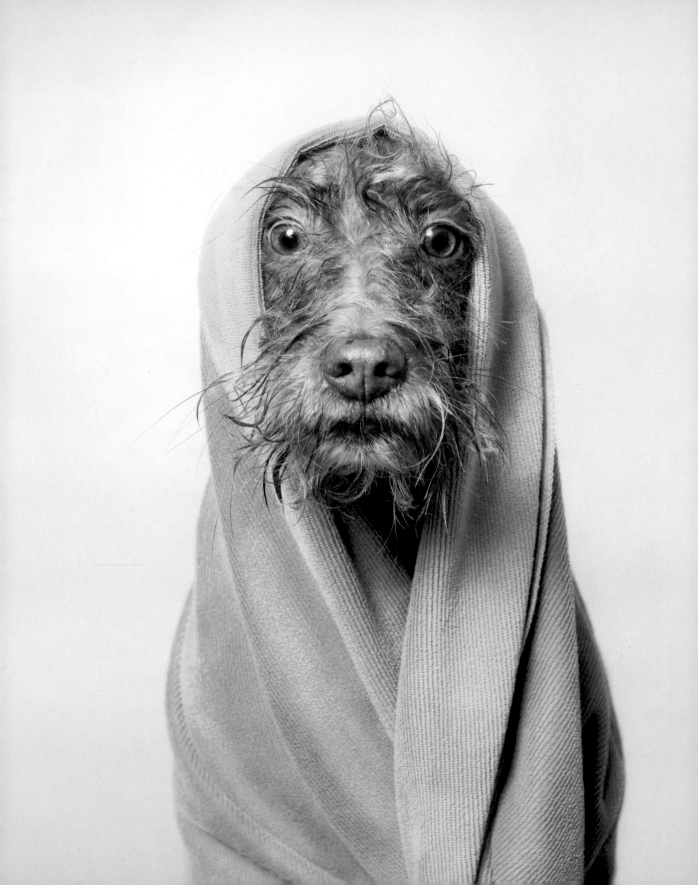

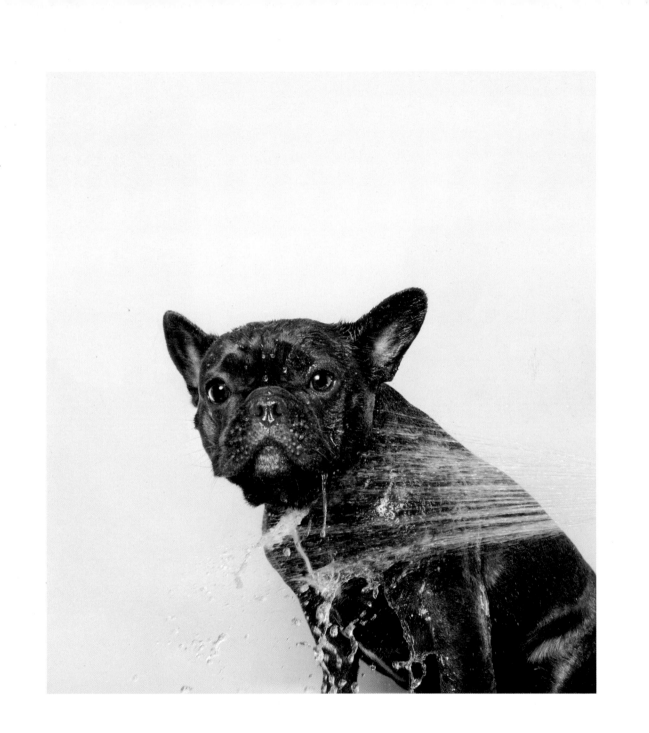

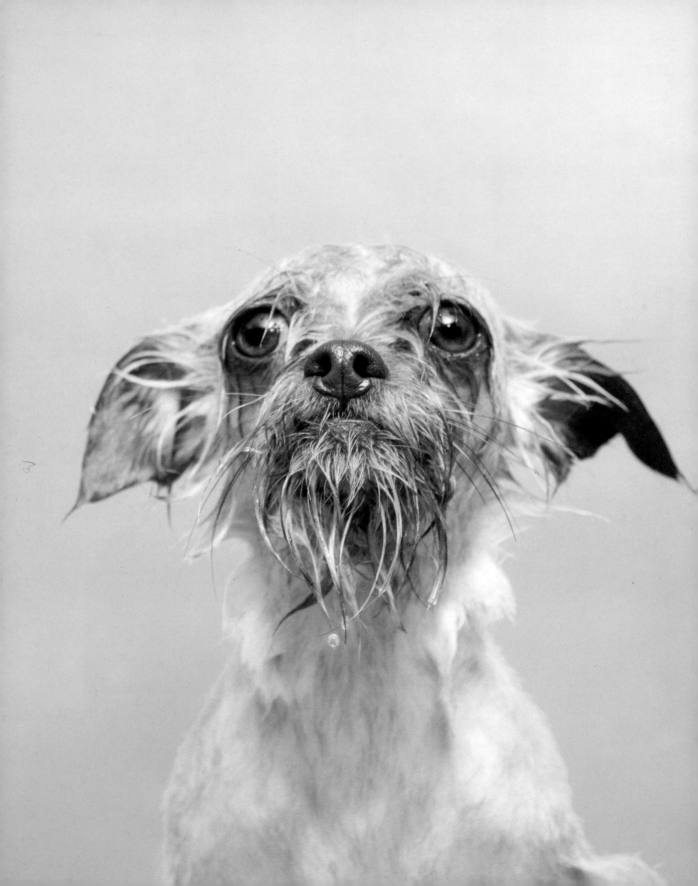

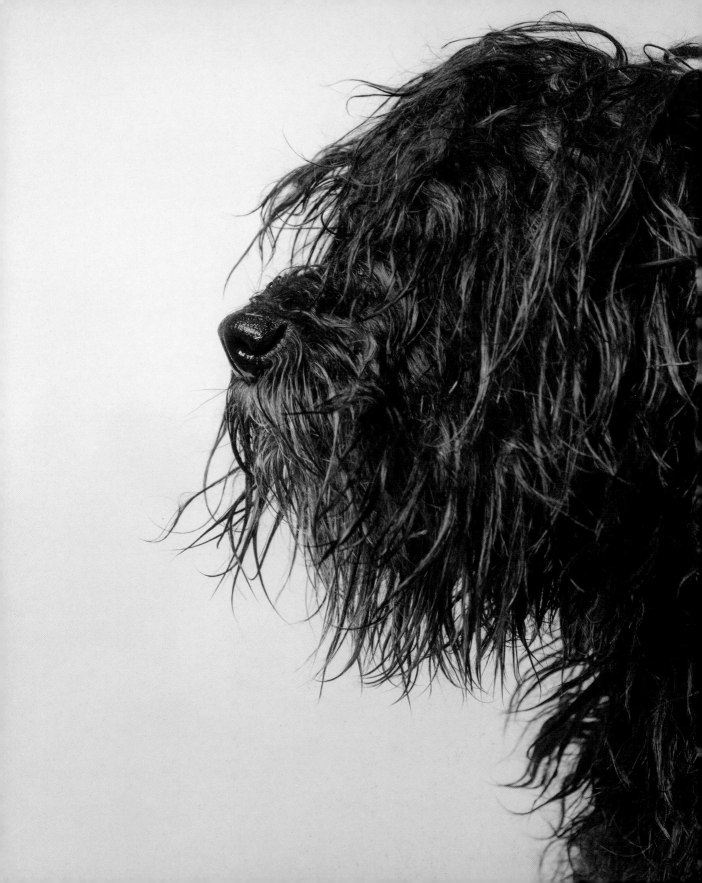

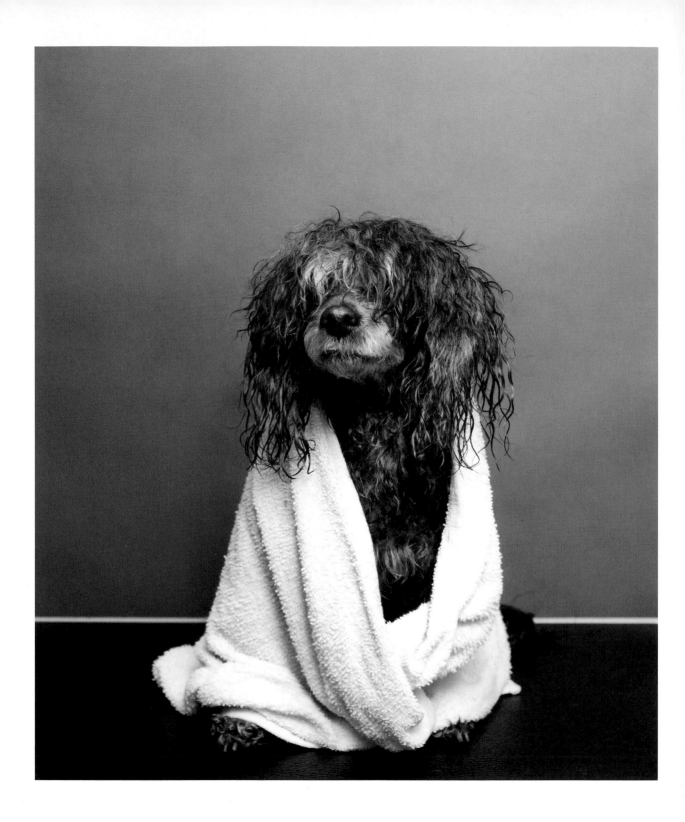

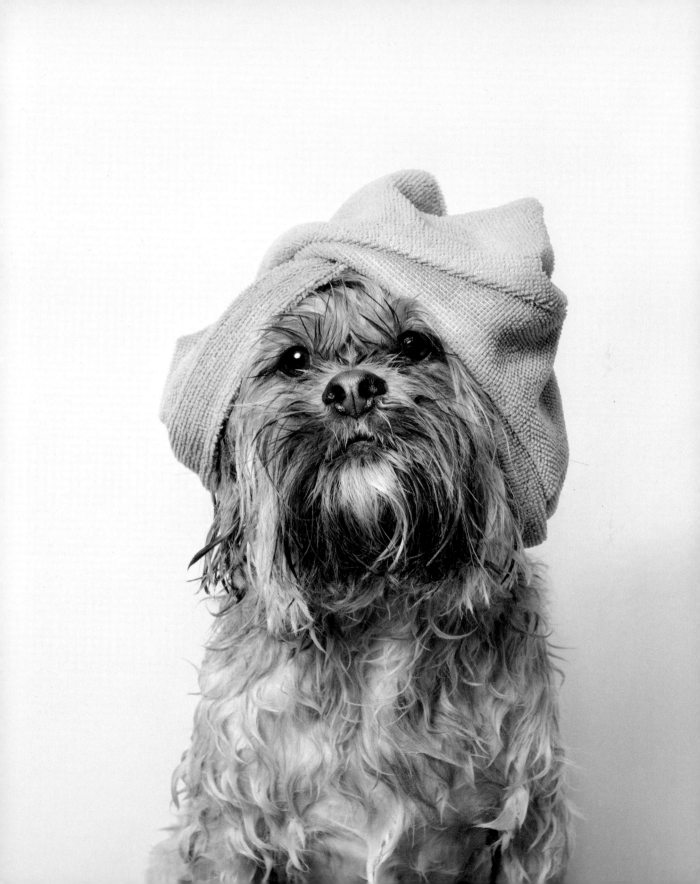

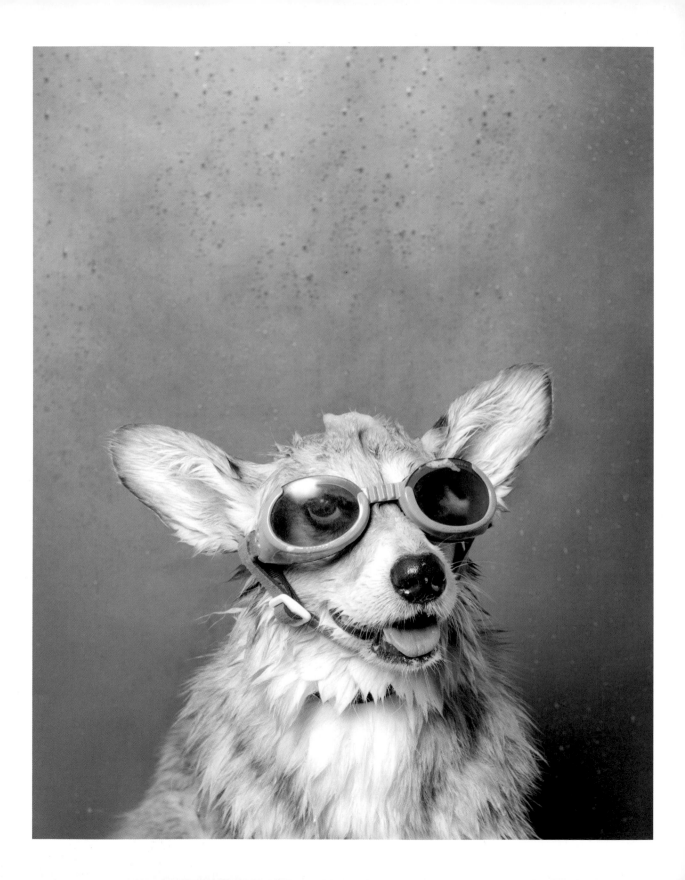

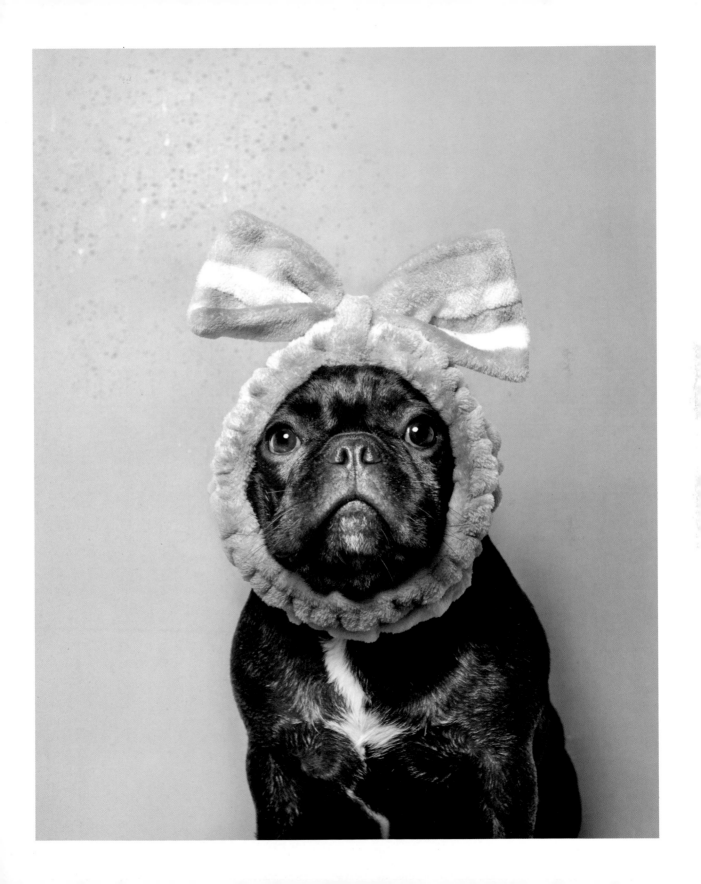

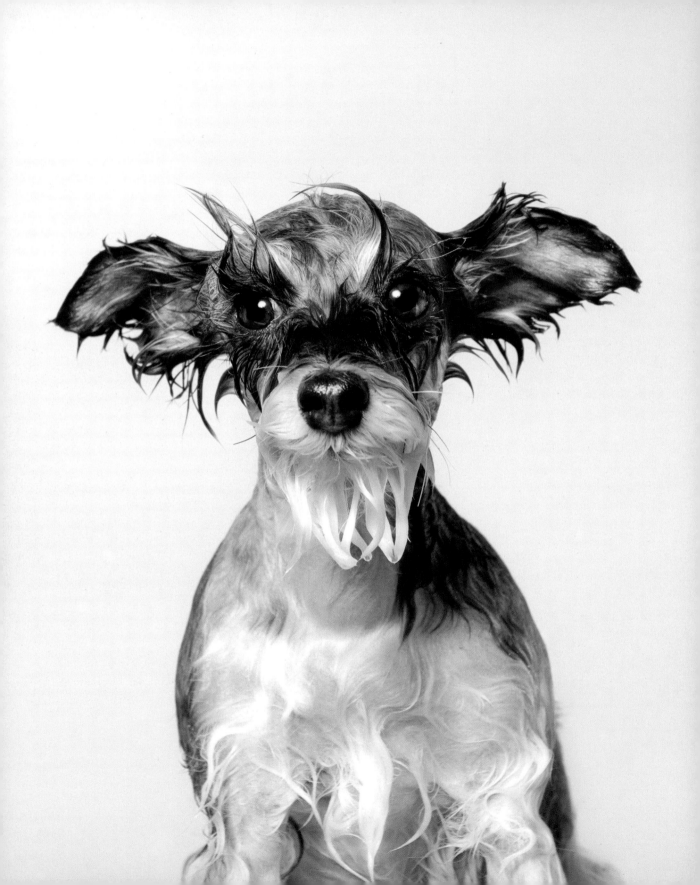

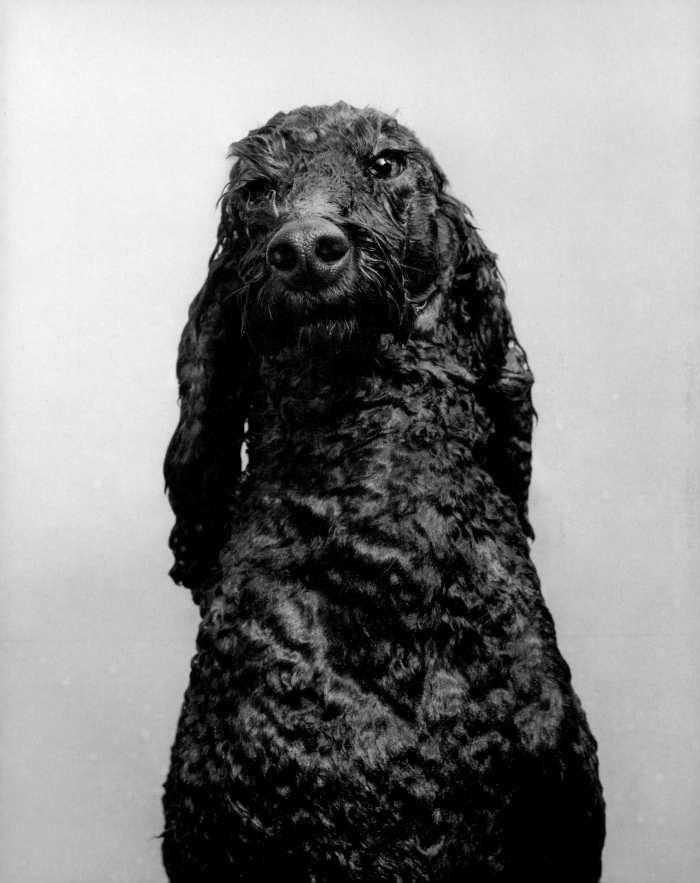

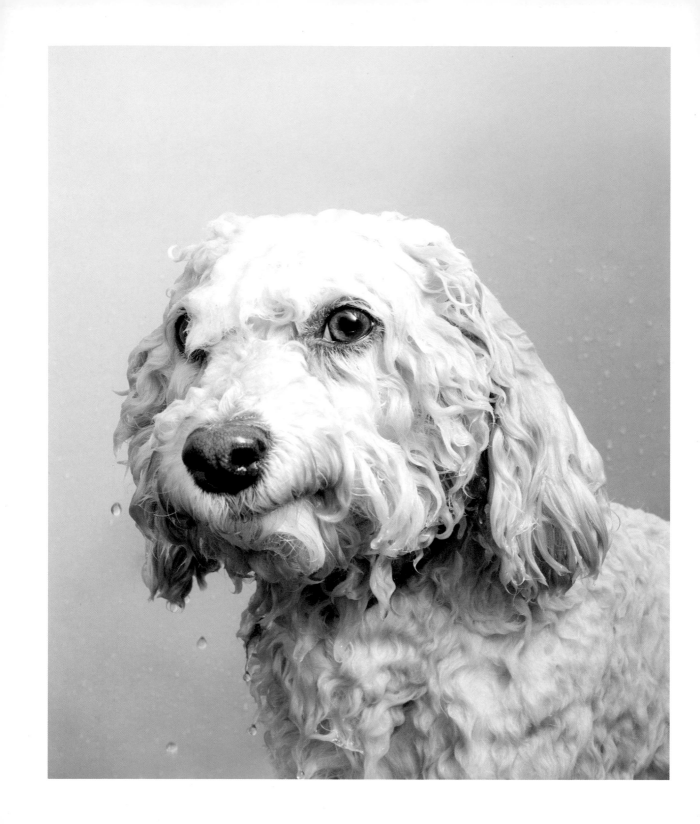

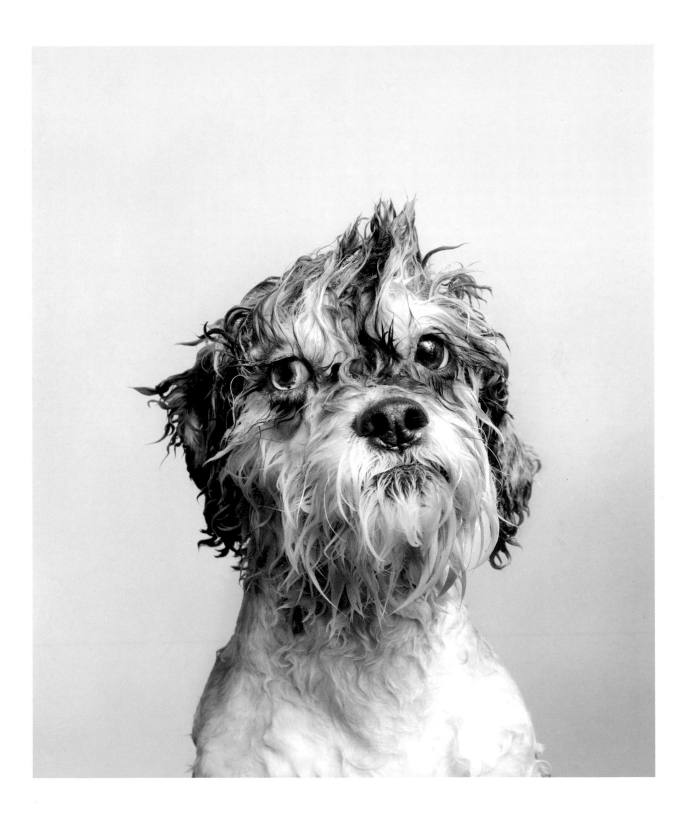

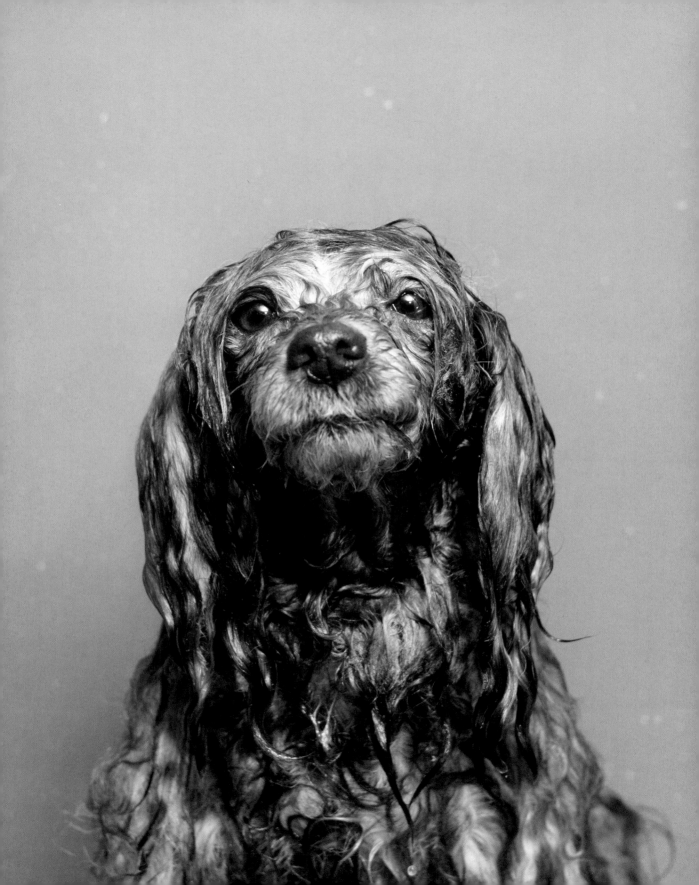

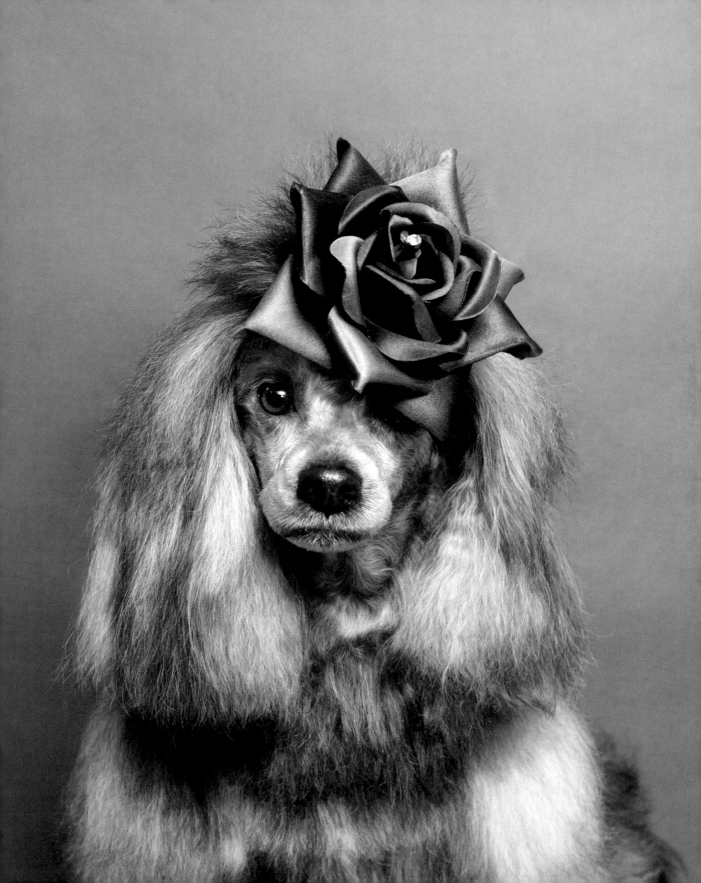

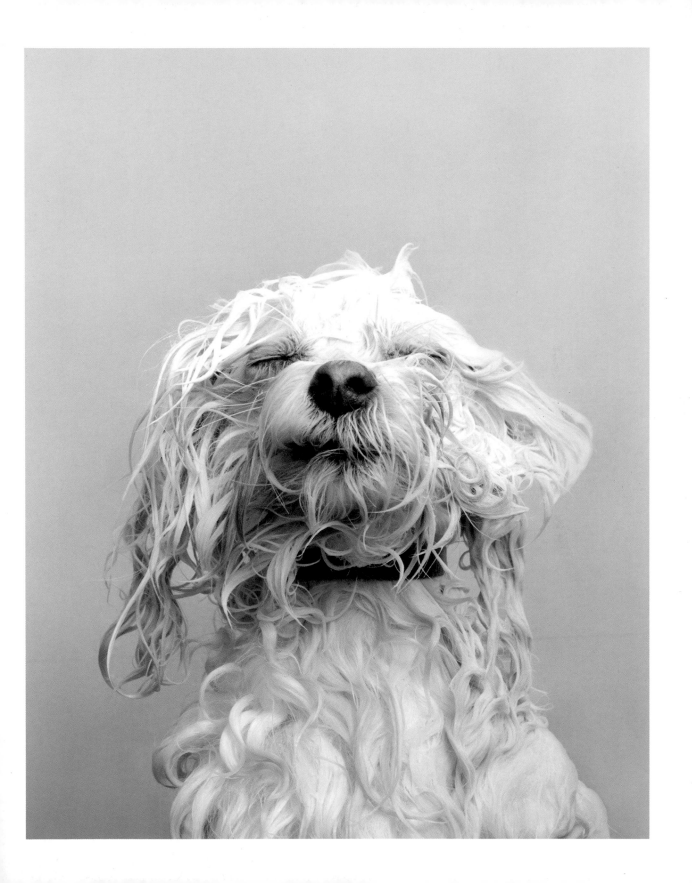

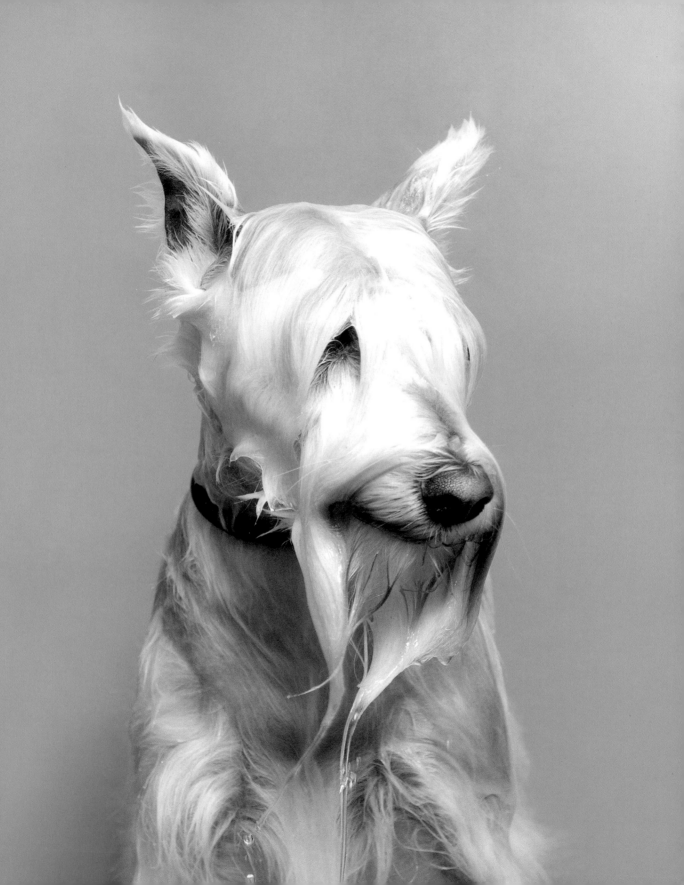

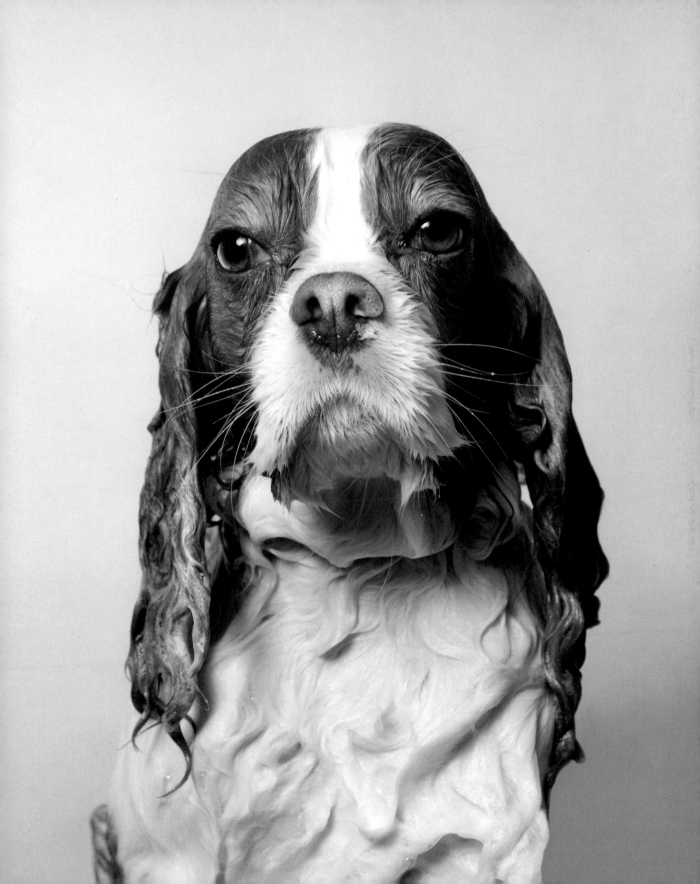

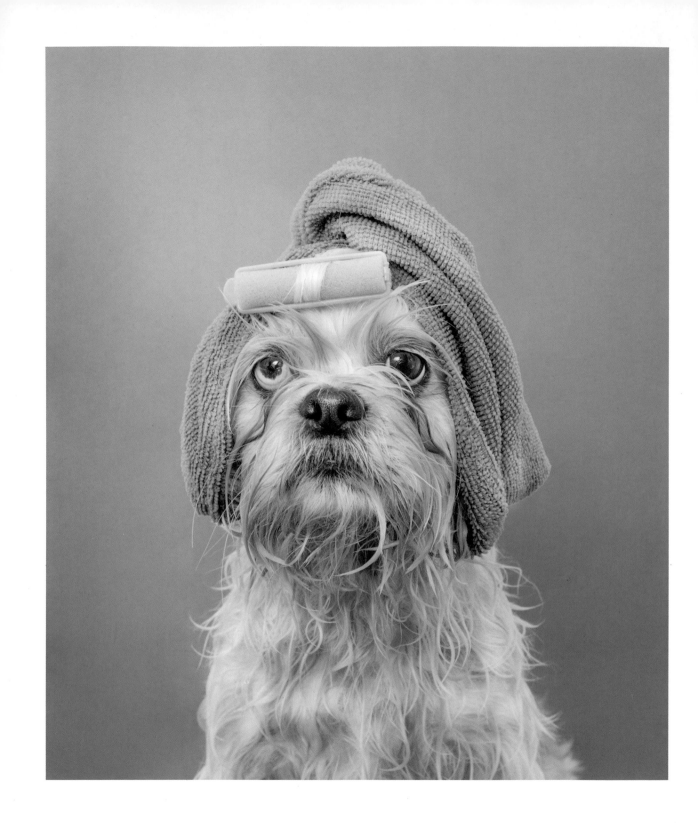

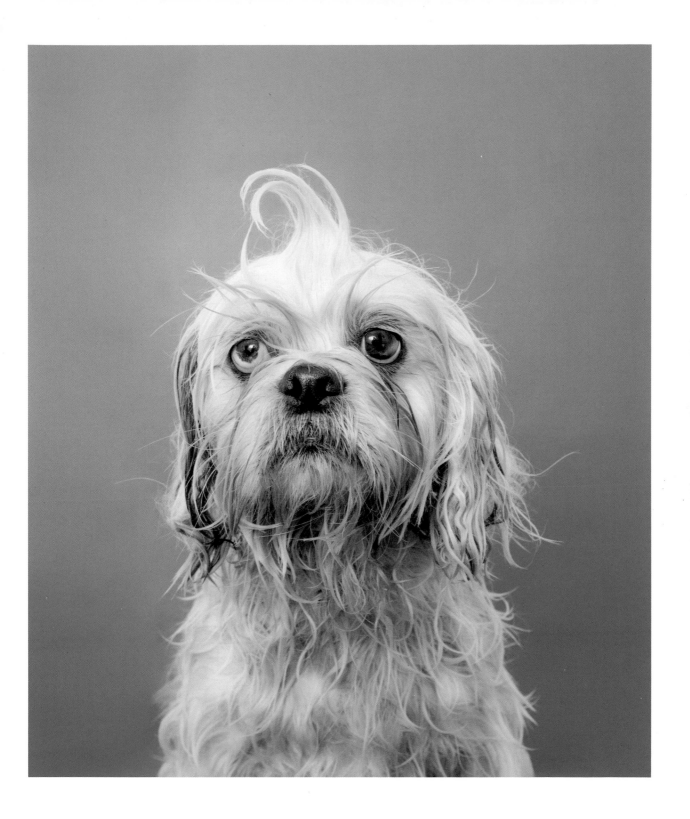

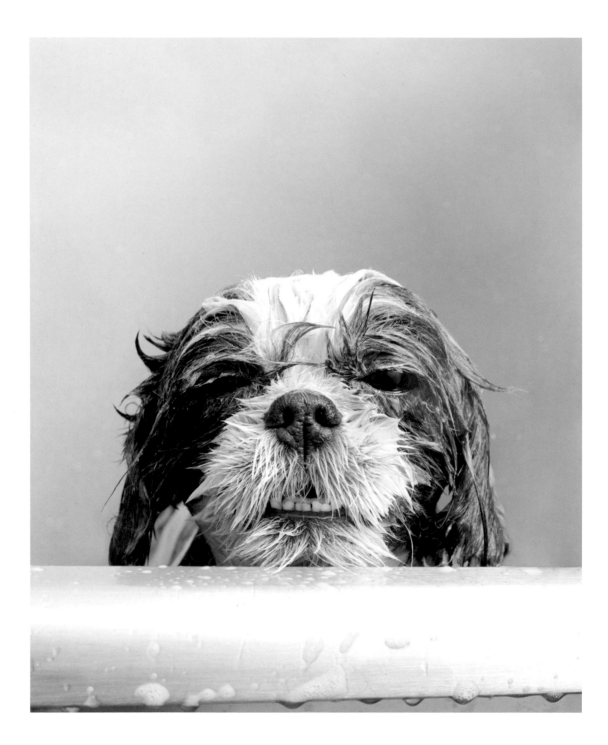

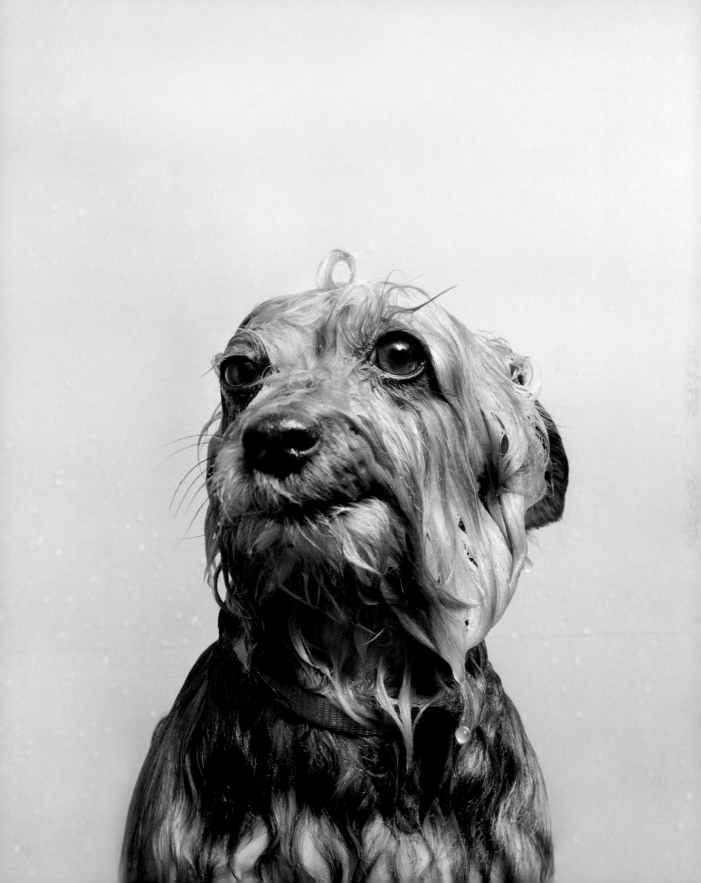

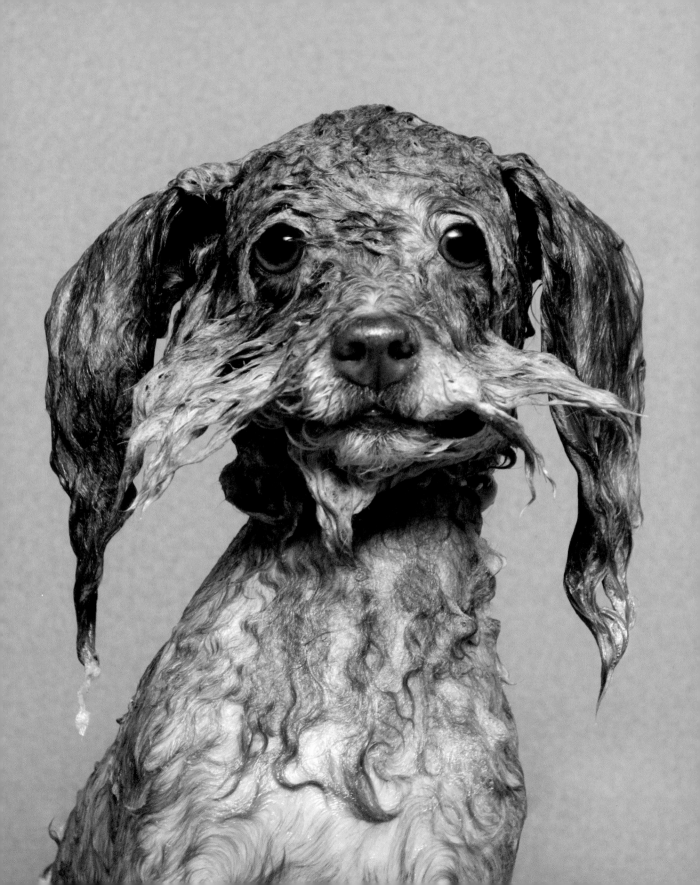

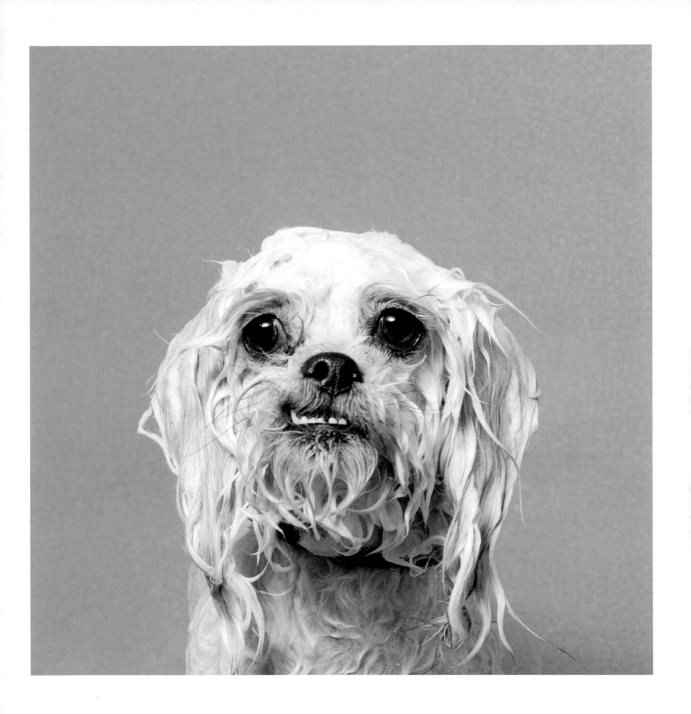

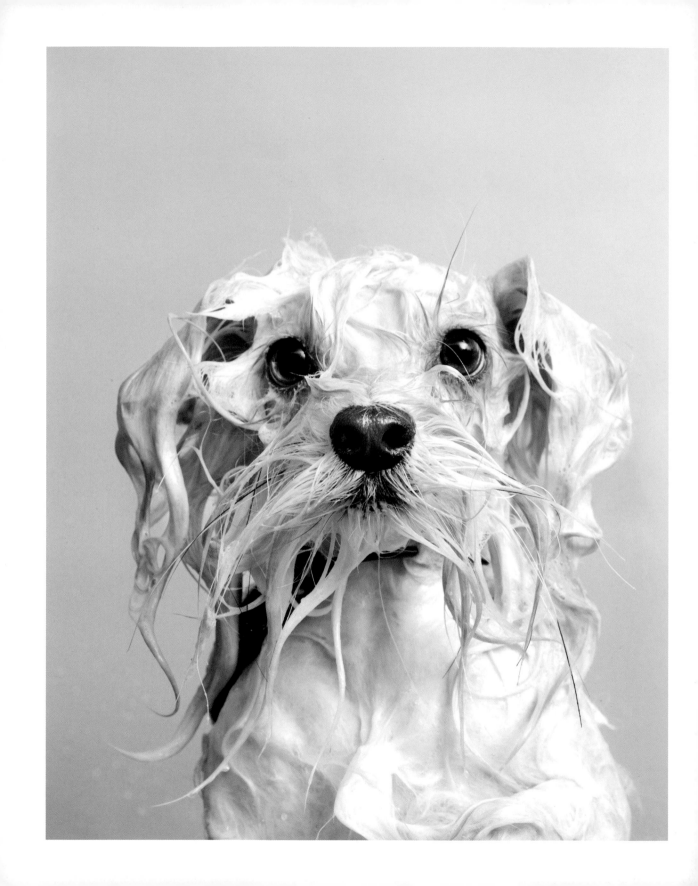

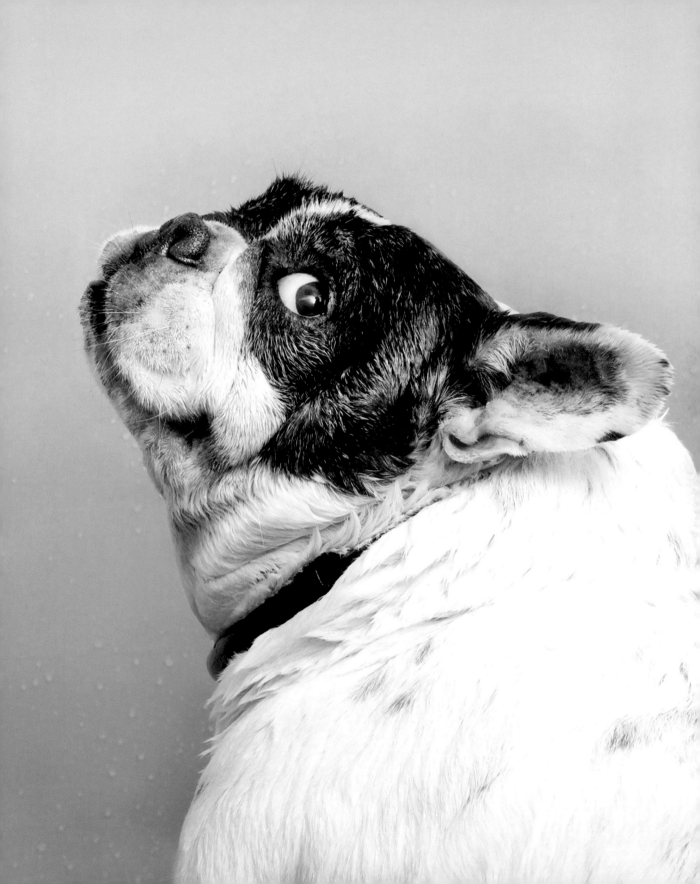

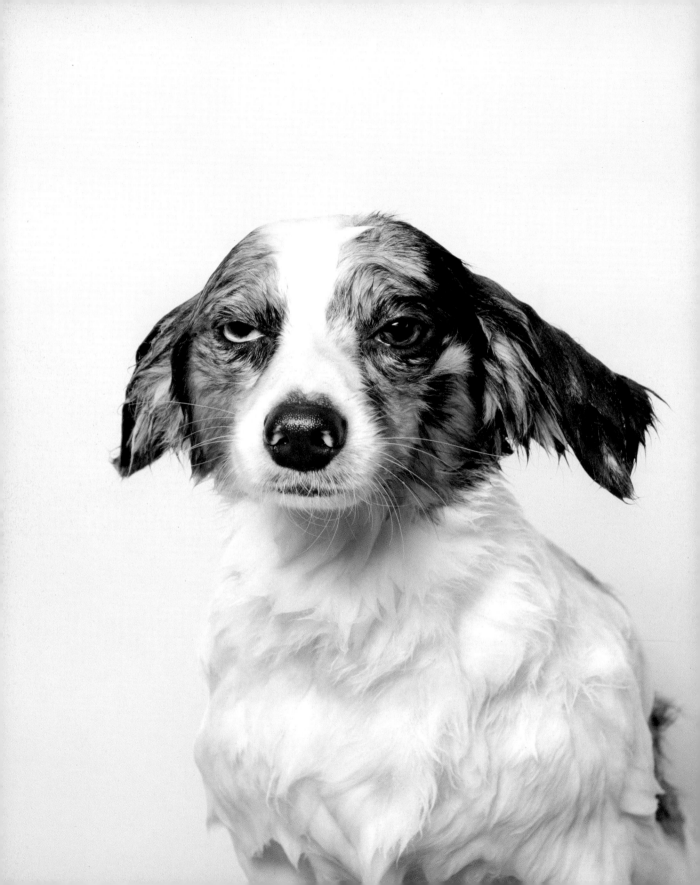

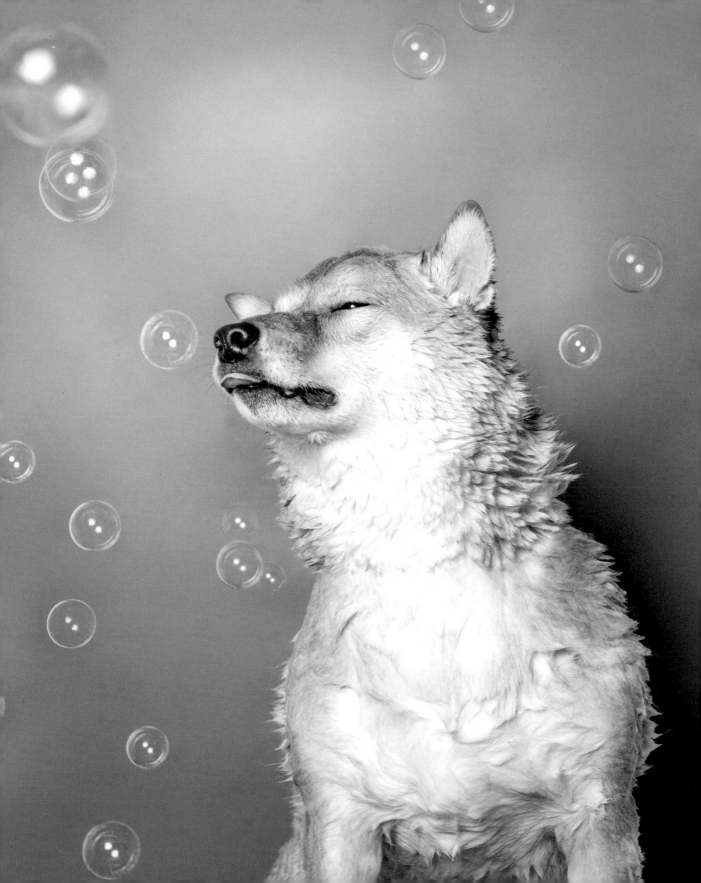

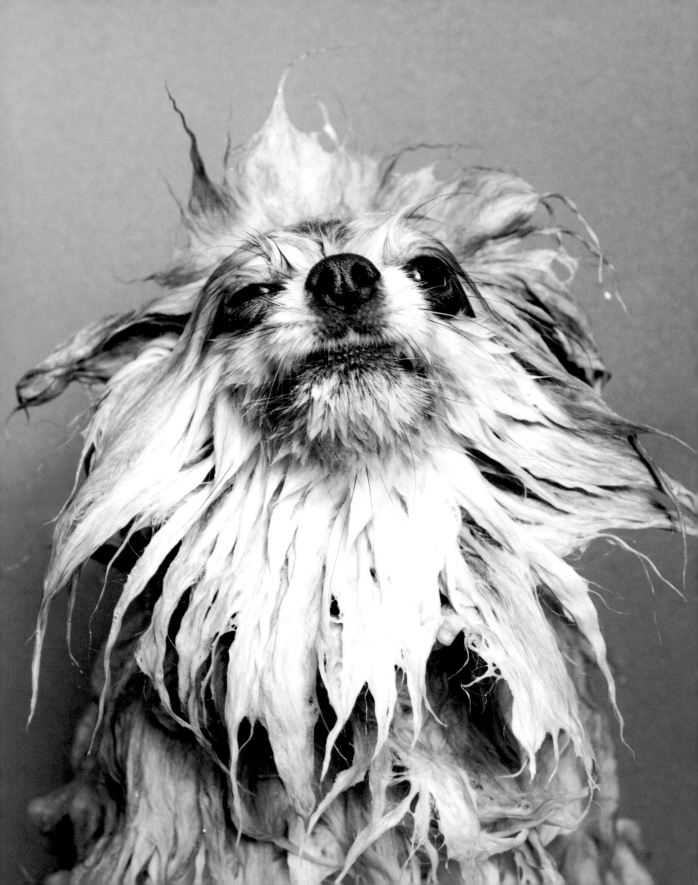

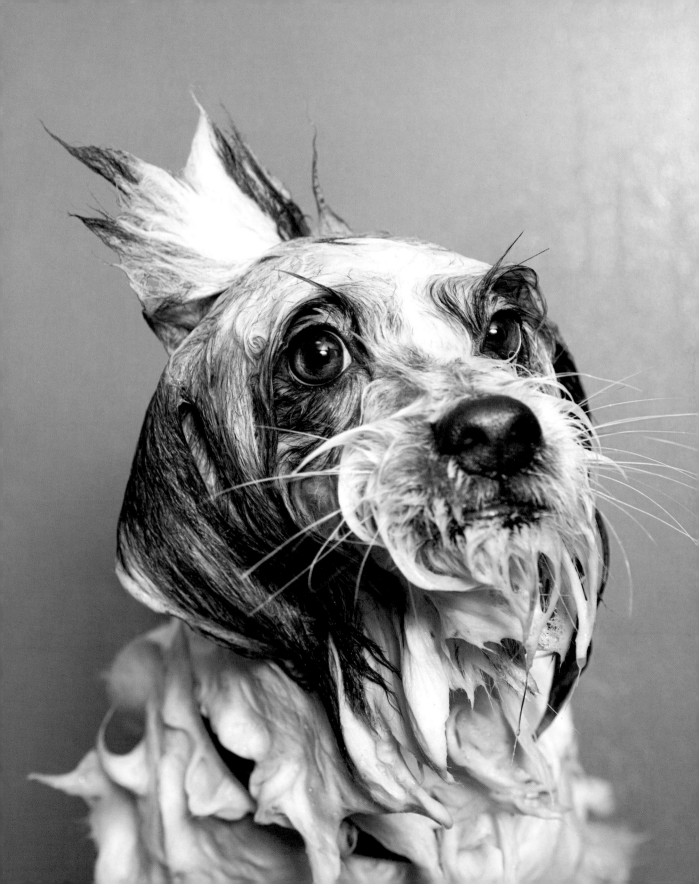

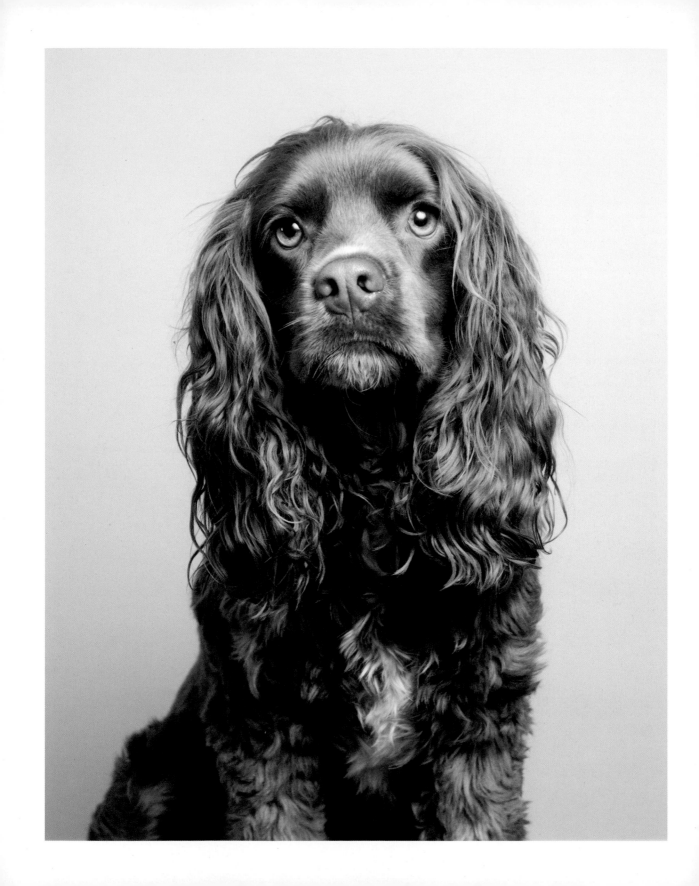

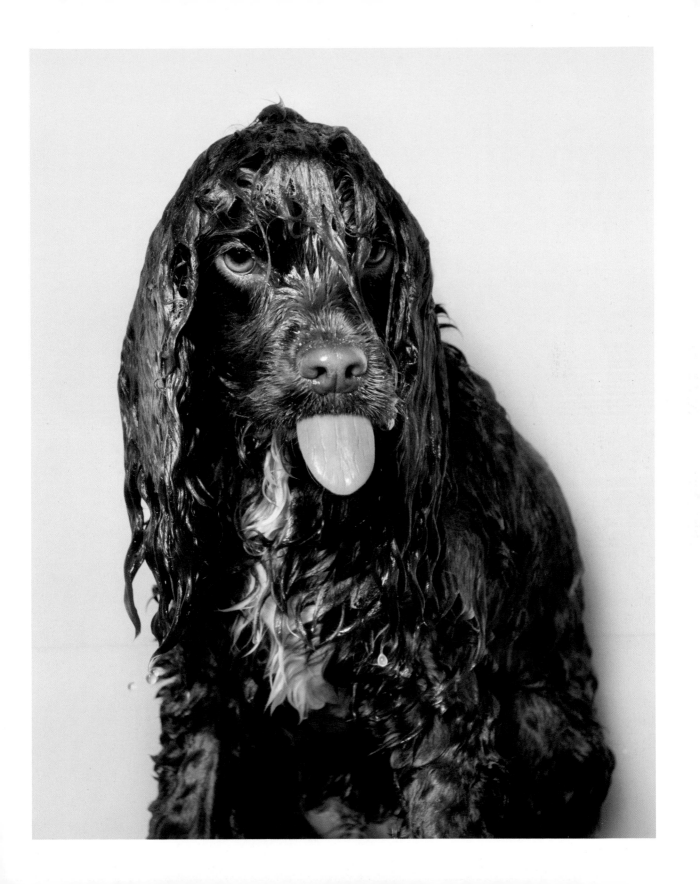

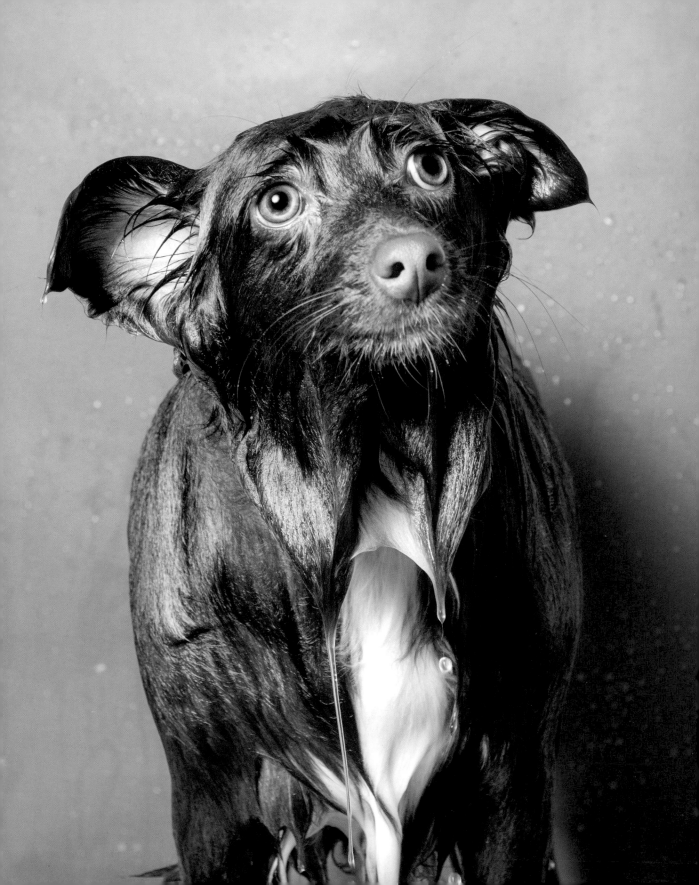

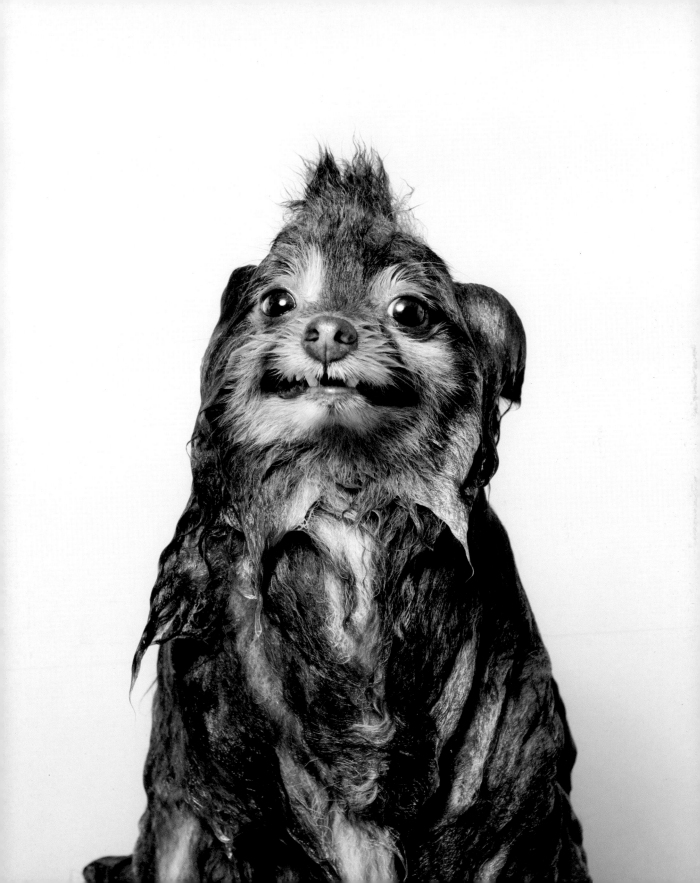

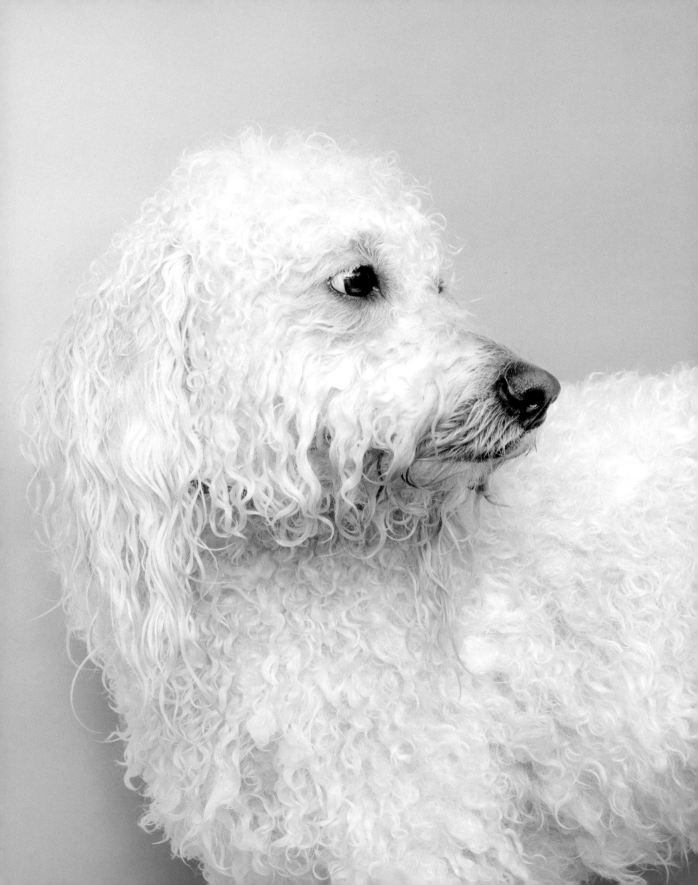

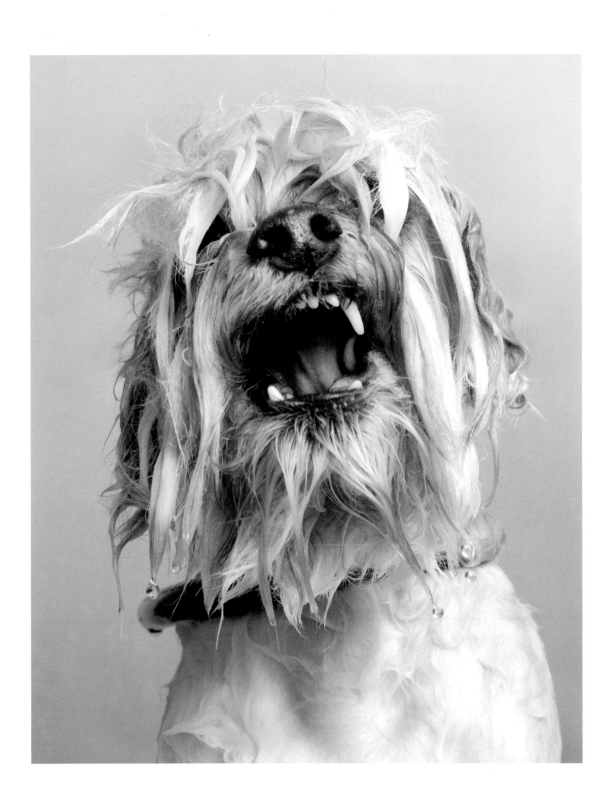

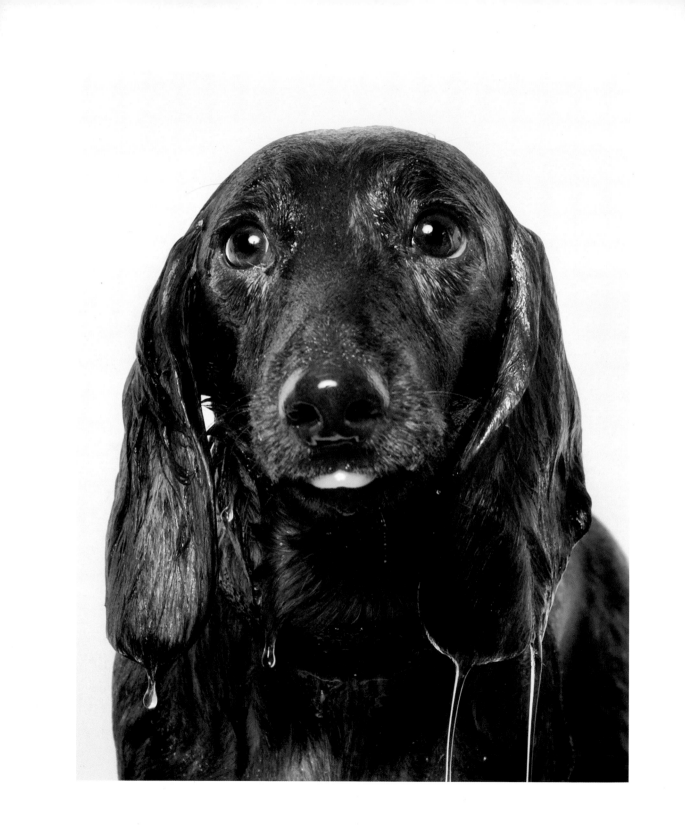

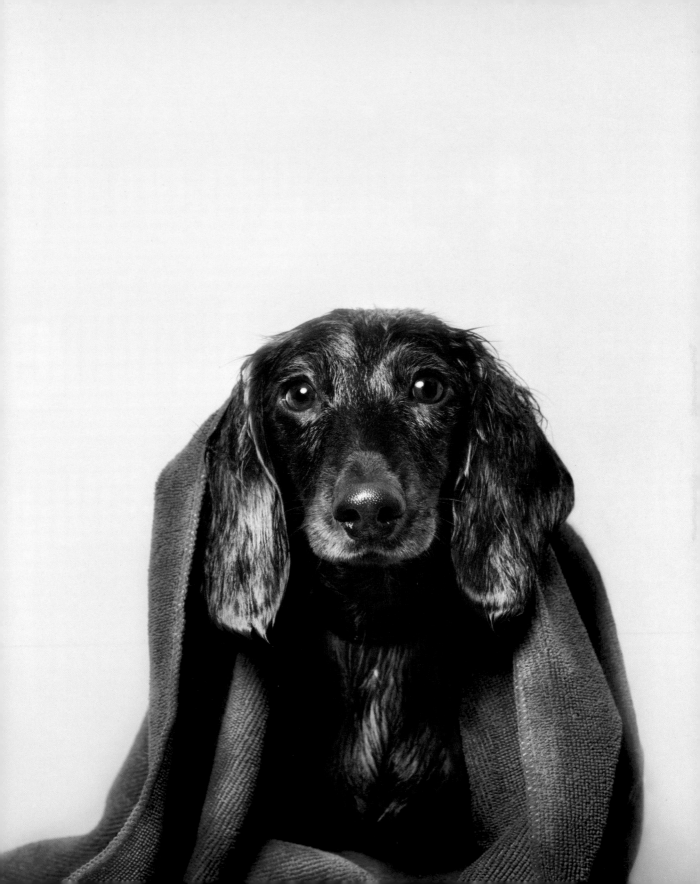

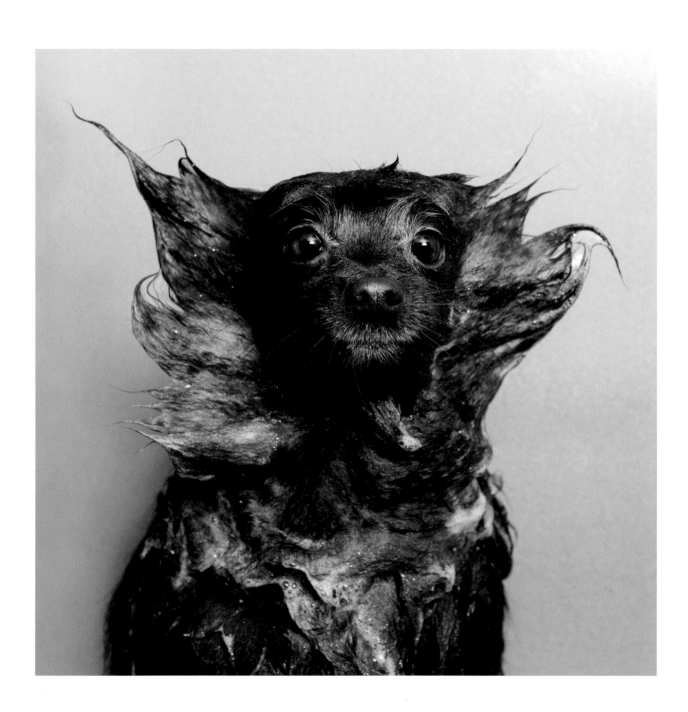

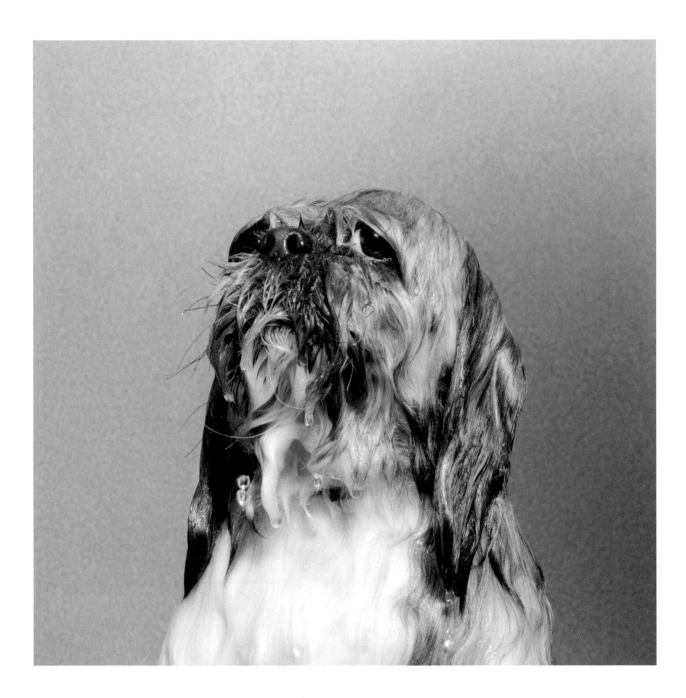

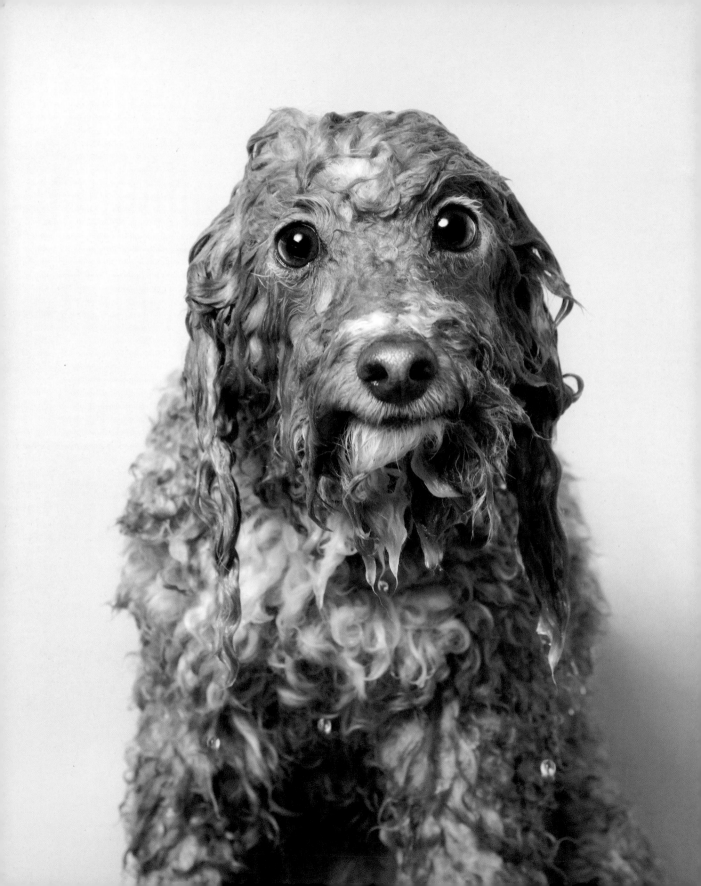

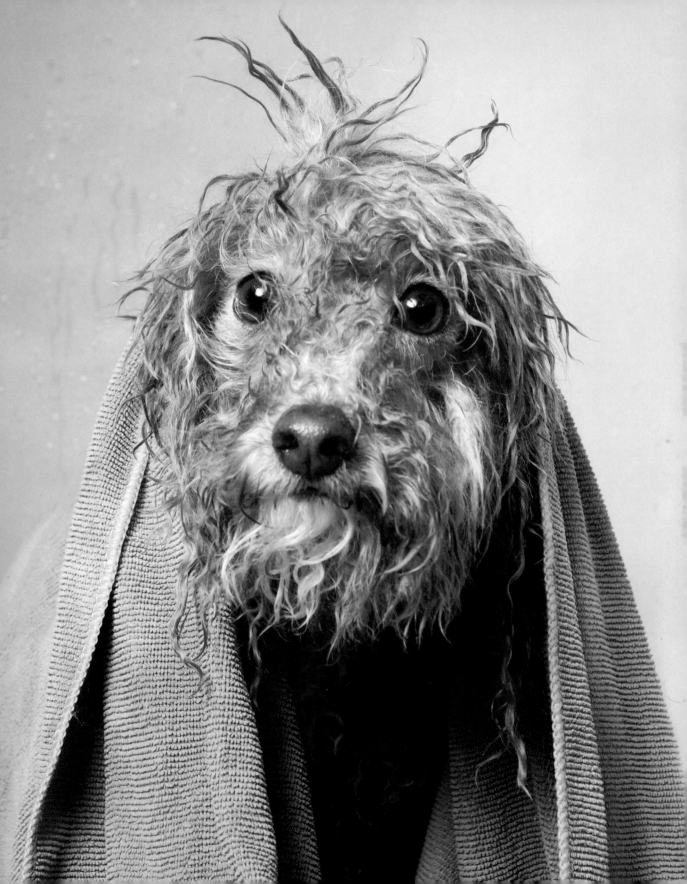

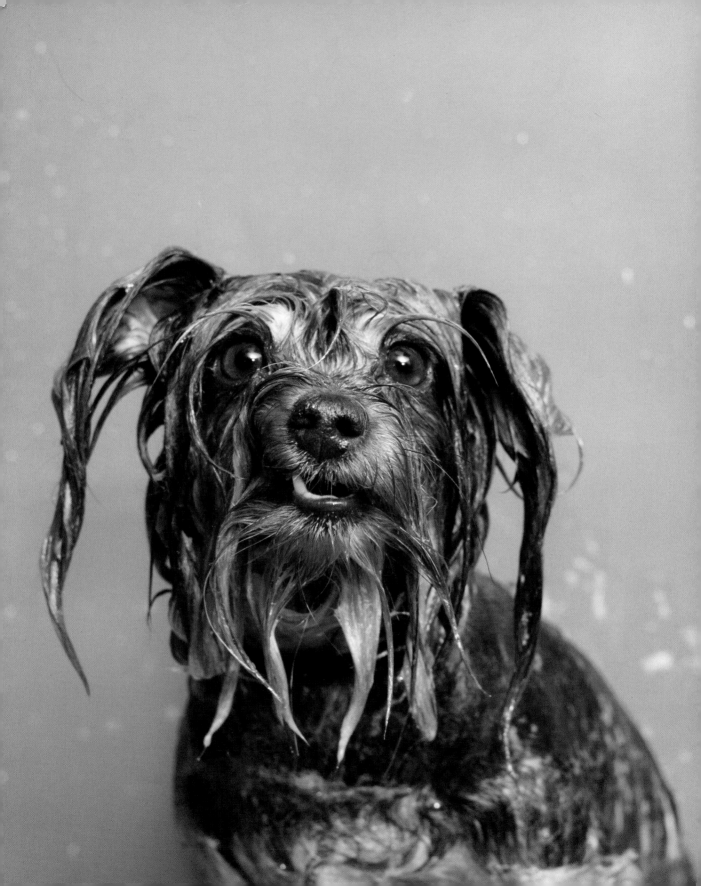